THE

2

Catalogue of the exhibition held in the Biblioteca Medicea Laurenziana from 15 February to 31 July 2008.

Exhibition design
Fabrizio Monaci, Roberta Paganucci

Photographs
Biblioteca Medicea Laurenziana, Florence
By permission of the Ministero per i Beni e le Attività Culturali.
Unauthorized reproduction is strictly prohibited.

The Library wishes to thank the Opera Medicea Laurenziana, the Istituto Centrale di Patologia del Libro, the Istituto Papirologico "G. Vitelli" and Mandragora.

Mandragora s.r.l.
piazza del Duomo 9, 50122 Firenze
www.mandragora.it

English translation by
Catherine Bolton

Edited, designed and typeset by
Monica Fintoni, Andrea Paoletti, Michèle Fantoli, Paola Vannucchi

Printed in Italy

ISBN 978-88-7461-116-4

BIBLIOTECA MEDICEA LAURENZIANA

the shape of the book

FROM ROLL TO CODEX

(3rd century BC–19th century AD)

edited by FRANCA ARDUINI

with an essay by GUGLIELMO CAVALLO

Mandragora

PREFACE

It is impossible to establish exactly when the book was invented or first began to circulate. Indeed, none of the forms exhibited here can be considered the embryo of what we have come to refer to as books. Nevertheless, if we narrow our scope to the Laurentian manuscript collection—in itself quite extensive—it would appear that the potsherd on which, probably under dictation, a pupil from the 2nd century BC wrote the ancient verses of one of Sappho's odes marks the most significant threshold of its history; the fragment represents the longest extant portion of the poem, which may have been dedicated to Aphrodite. The ostracon is a rare medium due solely to the fact that, since it is a fragile material that was not used for anything meant to endure, large quantities have not been handed down to us. The book form we chose as our endpoint—and thus closer to our own era—is a 19th-century Japanese erotic-grotesque scroll expressing a genre that enjoyed widespread and lasting circulation because of its caricatural and entertaining contents. Due to its distant provenance, however, it is a rarity in Italian libraries. Between these two intentionally striking extremes, we have created an itinerary that requires some explanation.

The exhibition has been divided into two separate sections. The first one, the Papyrus Collection, is composed of several documents from the Biblioteca Medicea Laurenziana's priceless collection. It offers a virtually complete range: from ostraca to fragments of papyrus rolls with literary, juridical, liturgical and administrative texts; lead and waxed wooden tablets; papyrus and parchment codices; and the fragment of a parchment codex from the 4th century AD, which also serves as a link to the next section. The decision to keep the first section separate from the

second one, the Manuscript Collection, is the logical consequence of a historiographic and scientific approach whereby all texts written on papyrus and, by extension, on lightweight portable materials (e.g. metal, ostraca, tablets) come under a specific discipline, papyrology, which has its own codified research and descriptive methods that differ from those used for manuscripts. Furthermore, this decision was dictated in part by the desire to pay a tribute to two milestones that will be celebrated in Florence in June: the centenary of the foundation of the Società Italiana per la Ricerca dei Papiri Greci e Latini in Egitto (Italian Society for the Discovery of Greek and Latin Papyri in Egypt), to which the Biblioteca Laurenziana owes some of its treasures, and the 80th anniversary of the foundation of the Istituto Papirologico 'G. Vitelli', which is tied to the Library by enduring friendship, research and working relations.

As its name implies, the second section of the exhibition focuses on the manuscript collection. Those on display have been selected in order to illustrate the relationship between book form and function in the Western world, although there are also examples from the Far East.

From a chronological standpoint, the history of the structure of the book is also marked by other criteria. The codex form—made of parchment and subsequently paper—was eventually adopted, and the examples shown here come from production centres ranging from the monastic scriptorium of Corbie to the imperial one in Constantinople and to high-quality workshops in Italy (and particularly 15th-century Florence), Europe and Asia, the latter represented by a sumptuous Persian manuscript. A *pecia* manuscript illustrates serial production. The *pecia* system, which was developed at medieval universities, consisted of the simultaneous copying of separate sections (referred to as *pecie*, 'pieces') of approved university texts. Unusual as it may be, the case of the 'Danti del Cento'—of which the Library owns one of the original models—is even more intriguing: it is one of the 100 copies of the *Divine Comedy* that the scribe Francesco di ser Nardo da Barberino supposedly produced so that he could afford to marry off his daughters.

A display case is also devoted to the Bible, the quintessential book, and it presents two antithetical formats: the monumental 'atlas-sized' copy from Santa Maria del Fiore, whose dimensions and decoration were designed to convey the importance of this text to the faithful, and the 'pocket-sized' version—the inseparable book of devotion—that, according to ancient tradition, Marco Polo brought with him to China.

Giovanni Boccaccio's miscellany offers an example of an autograph manuscript by a famous writer. The anthology of the works of scientist and intellectual Francesco Redi—part of which also written in the author's own hand—ends this series,

bringing us to the era of the private manuscript collections that accompanied but did not supplant the well-established libraries of printed works.

The last two scrolls date to the modern era (16th–17th and 19th centuries) and are from very distant places: China and Japan. Rare in Florence and at Italian historical libraries in general, these Eastern specimens illustrate the survival of a form that was essentially replaced by the codex in the West, where rolls nevertheless continued to be used chiefly for liturgical and documentary purposes.

Examples of the most widespread forms are displayed between the sections as an essential link between the two. The descriptions of these items in the catalogue and the captions focus on the format of the book rather than its contents. Consequently, we find the essentially square format of the codex, which has been documented since the 4th century AD and continued to be used until at least the 11th century; the oblong rectangular format that was common from the 11th to the early 13th century and was used mainly, although not exclusively, for Latin poetry; and the 'normal' rectangular format that was typical of humanistic codices and has been handed down to our own era, although with different measurements. The small Jewish prayer book for personal use, the scroll—also in Hebrew—with one of the five scriptures read during liturgies (*Megillot*) and a late example of a vertical decorated Ethiopian magic scroll offer examples from other cultures and areas.

The entries, which are the work of Rosario Pintaudi and the librarians of the Biblioteca Laurenziana, are introduced by Guglielmo Cavallo's essay. Long a friend of the Library, Professor Cavallo wanted to contribute to this exhibition by offering readers and visitors a brief overview of the history of the book, a field in which his expertise is virtually unparalleled.

We also received fundamental suggestions from Professor James Cahill of the University of California, Berkeley, for the description of the Chinese scroll, and Professor Giovanni Peternolli of the University of Bologna, for the Chinese and the Japanese scrolls. We are immensely grateful to both of them for their generosity, kindness and prompt assistance.

Franca Arduini
Director, Biblioteca Medicea Laurenziana

On rolls, codices and other aspects
of ancient and medieval written culture

GUGLIELMO CAVALLO

> Pray tell me, Euthydemus, is it really true what people tell me, that you have made
> a large collection of the writings of 'the wise', as they are called?

In response to Socrates' question, the young Euthydemus responded:

> Quite true, Socrates, and I mean to go on collecting until I possess all the books
> I can possibly lay hold of.

This dialogue, quoted by Xenophon (*Mem.* 4.2.8), reveals that manuscript books were produced and collected in the 5th century BC. The oldest extant specimens, datable to the late 4th century BC, are rolls (*volumina*) that were made of papyrus —writing material made from the papyrus plant—and had specific characteristics. Consequently, books in the form of rolls had evidently been employed for some time and, in any event, since the era of Socrates and Euthydemus. Papyrus was introduced to Greece from Egypt quite early, making it possible to produce this type of manuscript, as reconstructed for periods prior to the 4th century through various types of evidence such as literary sources, inscriptions arranged as *volumina* and rolls depicted on Attic vases. Before papyrus was adopted in Greece as the common writing medium for rolls, however, it seems that literary works were copied onto hard or heavy materials—strips of leather, slate, lead sheets, wax tablets and perhaps even ostraca, or potsherds—on which the text was written chiefly by incising and was then assembled in some fashion. With regard to the 4th century BC, Diogenes Laërtius (3.37) noted that Plato's *Laws* were written on wax tablets and

that they were copied by Philip of Opus, probably on papyrus rolls. Lead sheets, wooden tablets (waxed or unwaxed) and ostraca continued to be used well after the archaic period, albeit for different purposes: sheets for esoteric and occult writings, tablets for sporadic and provisional texts or documents, and ostraca for schoolwork and other incidental uses.

When we talk about rolls from the Greek and Roman periods, we are generally referring to papyrus rolls, as there is little direct evidence of rolls made of parchment, another writing material used since antiquity and produced from animal hide. How was a papyrus roll made, written and read? Sheets, referred to in Greek as *kollemata*, were made of thin strips of papyrus obtained from the stalk of the plant. The strips were overlaid at right angles (half of them were laid horizontally and half vertically), pressed together and then dried in the sun. The sheets were joined laterally by gluing—these joins are known as *kolleseis*—to form *volumina* (rolls) of a standard length (*c.* 3.40 m), which were sold for different writing purposes. Commercial rolls, which were cut or joined, were then used to make book rolls. The latter form, which was used from the 4th century BC until its decline in the 4th century AD, when it was replaced by manuscript codices, has been investigated extensively, studying not only surviving materials but also literary and iconographic sources.

The rolls were opened horizontally and their length varied according to the size of the text they contained as well as the type of script and column layout. Their length varied from 3 to 15 metres (there were no appreciable differences from one era to the next), although 'deluxe' manuscripts seem to have been an exception, as some of these rolls were more than 20 metres long. It has been calculated that for certain types of poetry the average length was between 3.5 and 8 metres. However, the height of the rolls varied according to the period, the place of production, the type of text, and the quality and function of the book. The most common documented heights are approximately 19–25 centimetres for the Hellenistic period and 25–33 centimetres for the Roman era.

The text was generally written on the side on which the papyrus fibres ran horizontally and was arranged in evenly spaced columns; the width of these columns could vary. *Scriptio continua* was used for all texts. Widespread in the Greek world and later also adopted by the Romans, it was a style of writing without word division. Sentences were roughly divided by blank spaces and critical signs, as the contents were conveyed by reading the text aloud, the most common practice in the ancient world (as opposed to silent reading).

A roll normally contained either one book from a given work (for example, one of the books from Xenophon's *Hellenica* or Livy's *History of Rome*) or a single au-

tonomous work (one of Sophocles' tragedies or a comedy by Aristophanes or Plautus). In the case of short texts such as the books of the Homeric poems or Demosthenes' *symbouleutikoi* speeches, a roll could contain more than one textual unit, whereas very long books would be divided into two tomes/rolls. The author's name and the title of the work, as well as the book number in the case of works divided into several tomes, were indicated at the beginning of the roll on the outside or on a label—*sillybon* or *sittybon*—that was always affixed to the outside along the upper edge of the roll. They could also be indicated in the manuscript in the *agraphon* (the section that was left blank at the beginning of the text), over the first column of writing, at the end of the text under the last column and/or in the final *agraphon*. In some cases the title was listed both at the beginning and at the end. Some rolls indicated the number of lines—always at the end of the roll, however, and strictly for copies made by paid scribes—in order to calculate remuneration for the work; these figures are sometimes written in Attic numbers.

In many cases rolls that were no longer used—and this was true not only for books but also documents—were recycled by writing texts on the reverse, i.e. the side on which the fibres ran vertically. Several ancient literary works, such as Euripides' *Hypsipyle* and Aristotle's *Constitution of Athens*, have survived solely on reused rolls. It is important to note that, while there was no lack of parchment rolls—particularly outside Egypt, where papyrus was produced—very few examples have survived. The fragment of a theatrical work from Ai Khanum, in Bactria, which has been reconstructed based on an impression and is thought to have been written originally on parchment, biblical texts from the Palestinian sites of Qumran and Nahal Hever, and the section of a parchment roll of Xenophon's *Symposium*, discovered in Antinoë (Egypt) but probably produced in Mesopotamia, give us some insight into what these rolls must have looked like in the Hellenistic and Roman periods.

Once the text was written, the material would either be wound around rods (a single staff or one at each end; they could be fixed or mobile) or rolled up around the initial section, which was tightly coiled and glued. To read the text, one would hold the roll in his right hand, using his left to unwind it and simultaneously rewind the part that had already been read. When the reader was done, the roll would be completely wound in his left hand, so that to read it again he had to unwind and then rewind it to return to the beginning of the work.

Commercial rolls were cut or joined to make not only books but also documents. Egypt has yielded an immense amount of documentation from every era: Ptolemaic, Graeco-Roman and Byzantine. The papyri from the Zenon Archive date back to the 3rd century BC. These records, which pertained to a Greek from Asia Minor

who entered into the service of the *dioiketes*, or finance minister, Apollonios, include official documents, but the bulk is made up of an enormous collection of private papers. Later archives, such as those of Heroninos, Flavius Abinnaeus and Dioscorus, are equally important in terms of quantity and quality. In short, an immense number of documents of all kinds have re-emerged from the Graeco-Egyptian *chora*. To cite only a few of the types of public and private documents involved, there are edicts, circulars, petitions, reports, registrations, court records, official and private letters, wills, contracts, mortgages, receipts, notices and sureties.

Starting in the late 1st century AD, rolls were slowly supplanted by a new manuscript form, the codex, which originated in Rome and the Roman world. It was modelled after tablets assembled to form polyptychs, whose use for literary works has been documented as far back as the era of Cato the Censor (3rd–2nd century BC). The new codex book form arose when tablets were replaced by sheets of parchment (in the Western Roman world) or papyrus (as was often the case in the Graeco-Oriental area, particularly Egypt). Martial's poems circulated in this form at the end of the 1st century AD (Martial 1.2.1–4), and Martial himself cited parchment manuscripts with the works of Homer, Virgil, Cicero, Livy and Ovid (14.184; 14.186; 14.188; 14.190; 14.192). Virgil's manuscript even bore a portrait of the author on the first *tabella*. The codex offered various advantages that ensured its success: it saved writing material, as the codex was written on both sides of the leaf, unlike the roll, which was normally written on only one side; it was easy to use, as it could be held and read with just one hand or could be set on a bookrest; it had a larger capacity, as the codex could hold a much longer text than a roll and could thus contain several books from a single work (for example, all the books of Xenophon's *Hellenica* or one of Livy's decades) or several works by a single author (e.g. many of the plays by Sophocles, Aristophanes or Plautus); and its paginated layout facilitated reading and consultation, and made it easier to find or reread certain passages. Between the late 1st and the 4th century the codex became widespread throughout the Graeco-Roman world, albeit more rapidly for biblical texts and the new Christian literature. Indeed, Christianity is thought to have played a key role in its spread, whereas it was adopted more gradually for profane literature. Nevertheless, by the end of the 4th century the codex had largely replaced the roll and, tellingly, examples of the latter from the period between the late 4th and 6th centuries are extremely rare. In the Middle Ages the codex was produced in various sizes, from enormous and often daunting tomes to small 'pocket-sized' books.

After Late Antiquity there are sporadic examples of book rolls. However, the transition to the Greek and Latin Middle Ages also brought about a change in type and function: the roll, structured differently from a technical standpoint, was em-

ployed for rare and special purposes with respect to the general use of the codex. First of all, as a rule the medieval roll was no longer made of papyrus but parchment. It was composed of sheets stitched together in a vertical sequence and the text was written along the short side of the parchment, using a technique already documented in the ancient world—*transversa charta*—but used specifically for rolls containing certain types of documents. The text was thus arranged vertically and was read by unwinding the roll from top to bottom. Parchment rolls were widely used in Byzantium for the rites and liturgical officiations of the Graeco-Oriental church; although direct evidence of these rolls starts in the 8th–9th century, they may have originated earlier. In any case, in the 11th and, above all, the 12th century liturgical rolls were used extensively in Byzantium as books for certain rites. Although most of them contain the ordinary Byzantine rites—the liturgy of St John Chrysostom, that of St Basil the Great or both—some also have other liturgies or particular offices. In the Latin and then the vernacular traditions of the West, the vertical roll was used virtually throughout the Middle Ages. Rolls with compendia of biblical history, world and local chronicles, genealogies, medical and alchemical works, religious plays, lyric poetry and more are documented through both direct and indirect evidence, above all starting in the 12th century. However, rolls used for liturgical purposes have also been documented in the early Middle Ages.

The transition from roll to codex was paralleled by another significant change in bookmaking techniques that clearly emerges from the foregoing considerations: parchment gradually replaced papyrus as a writing material between the 4th and 8th centuries, although rolls should not necessarily be linked with papyrus nor codices with parchment. Parchment, which is much sturdier than papyrus, was made from animal hides (mainly sheepskin and calfskin). The sources also mention the use of other types of skins—deer, gazelle, antelope and even snake—but no evidence has survived. According to a curious medieval epigram, human skin is less valuable than animal hide, because with death it decays along with flesh and bones, whereas animal skins provide writing material.

A special procedure was used to make parchment. The hide was soaked in a lime bath and then stretched on a frame. Both sides were scraped to remove hair and flesh, after which the skin was left to dry. Lastly, it was smoothed with pumice. This procedure was very common during the Middle Ages, but there were also other processes. For example, in the East parchments were sometimes coated with egg white in order to bleach them. Parchment is said to have been invented in Pergamum in the 2nd century BC in response to the embargo that the Ptolemies had placed on the sale of Egyptian papyrus as a way to halt the development of the Attalid library and thus prevent it from rivalling the one in Alexandria. Since parch-

ment was obtained from animal hides, it could be made anywhere, unlike papyrus, which was produced almost exclusively in Egypt. Consequently, its use went hand in hand with the spread of the codex. However, the process did not follow a parallel course in the East and West. In the West, where parchment was used for various purposes even before Martial's era, there are very few Latin papyri datable between Late Antiquity and the early Middle Ages. Moreover, these manuscripts are attributable to very specific contexts, whereas the use of parchment was widespread by the 3rd or 4th century. In the East, on the other hand, this transition was very slow and was correlated with the type of text, the choice of what to publish, the patrons' sociocultural environment and the function of the book itself. Despite the drawbacks posed by the fact that most of the evidence comes from Egypt, where papyrus was produced, it seems that, in general, the papyrus codex continued to be used between the 4th and 8th centuries, above all for secular books, which were written mainly in informal scripts—in short, they were utilitarian books. Parchment was instead used essentially for sacred books and almost exclusively for the Old and New Testaments, which were penned mainly in extremely formal scripts. Hence the corollary that, religious or secular content aside, Greek papyrus codices are extremely varied in their graphic and codicological aspects, whereas parchment codices are essentially fixed in their basic characteristics. In any case, in the Graeco-Oriental world as well parchment ultimately prevailed over papyrus.

Papyrus or parchment manuscripts were sometimes reused by erasing or washing away the text and writing a new one over it, and in this case they are known as palimpsests. Particularly in the Middle Ages and in certain circles, the use of palimpsests was quite widespread, above all in the outlying areas of the Byzantine Empire (Syria, Palestine and Greek-speaking Terra d'Otranto) and the Latin West (Ireland as well as monasteries, such as Bobbio, that were founded by the Irish on the European continent). Fragments of several works that would otherwise have been lost, such as John Malalas' *Chronographia* and Cicero's *De re publica*, were recovered from palimpsests.

A new writing material also came to be used alongside parchment during the Middle Ages: paper. Invented in China in the 1st century AD and known throughout the Arab world by the 8th century, this material—made from macerated rags—was first introduced to Byzantium through Syria, Palestine and Egypt, and subsequently to the West through Spain. A distinction must be made between unwatermarked paper and Italian paper bearing a watermark, i.e. a monogram or figured motif created in the sheet mould wire. Impressed onto the sheet, it not only identifies the papermaker but also makes it possible to date the paper fairly accurately. Oriental paper is always devoid of watermarks. Paper, which was used for Greek

manuscripts as early as the 8th–9th century, became more widespread as of the late 11th century, whereas it was not commonly used for Latin manuscripts until the 13th century.

The calamus was used in ancient times to write on both papyrus and parchment. An anonymous epigram from the *Palatine Anthology* (9.162) describes this instrument, a hardened reed dipped in ink, as follows:

> I the reed was a useless plant;
> for out of me grew not figs nor apple nor grape-cluster;
> but man consecrated me a daughter of Helicon,
> piercing my delicate lips and making me the channel of a narrow stream;
> and thenceforth, whenever I sip black drink, like one inspired
> I speak all words with this voiceless mouth.

The calamus was used for writing throughout the Byzantine era in the East, but in the West it was gradually replaced by quills towards the 4th century.

How was a codex manuscript made and organized? It was normally composed of a certain number of bound quires that, in turn, were composed of folded leaves made not only of parchment but also papyrus in earlier periods, and paper in the Middle Ages and the Renaissance. Only the earliest versions of papyrus codices were composed of a single large quire. The folded leaves, known as bifolia, were set inside each other to form quires that were chiefly composed of four bifolia (quaternion), although the number could vary. There are examples composed of two (binion), three (ternion), five (quinternion), six (sexternion) or—rarely—more bifolia. The advantage of parchment was that the animal skin could be folded and then cut to form a given number of bifolia. In the quires of older papyrus codices, the leaves with horizontal fibres faced those with vertical fibres, but in later ones they were arranged so that the fibres on facing leaves ran in the same direction. In parchment codices, regardless of how the quires were made, the leaves were collated so that—with very few exceptions—the same sides of the skin faced each other, i.e. flesh to flesh and grain to grain (this is known as Gregory's Law, after the scholar Caspar René Gregory, who first noticed this practice). In Graeco-Oriental codices the quire normally started with the flesh side of the parchment, whereas for Latin texts this custom is observed chiefly in older manuscripts and those from the humanist period. During the Middle Ages most quires started with the grain (or hair) side, a practice that has also been documented in Greek codices produced in southern Italy. The correct order of the quires was indicated by a number (signature) at the beginning or end of each quire, or at both ends. However, *reclamantes* or catch-

words were also used, i.e. the first word or words from the new quire were written at the end of the preceding quire.

While discussing ancient and medieval books, we must also examine illustrated books, works that were decorated not only with larger initials, distinctive scripts or ornamentation, but also had an iconographic repertory. In the illustrated rolls of the ancient world, the column of writing was broken up by images related to the text, a practice commonly referred to as the 'papyrus style'. With the codices of Late Antiquity and the Middle Ages, however, illustrations came to fill the entire page in a single 'frame' or several images were arranged in vertical registers: in short, they acquired a specific position with respect to the text. Whereas images merged perfectly with the surrounding text on rolls, embedded between the lines of writing, in codices they became independent entities, generating a visual discourse that did not always mirror the verbal message of the text but offered an alternative or different one, or had another significance. Consequently, the visual discourse or iconic text served as a gloss or reference, guiding the reader, interpreting the text and providing commentary. It underscored what the text merely implied; summarized it by merging several episodes into one; echoed an oral tradition, interfering with the written discourse; revealed hidden meanings through allegory; bent or manipulated the gist of the text according to given intentions or ideological orientations; and was transferred from one text to another in its original form or with adaptations and reinterpretations. By documenting the 'physical' detachment of the image from the text, the illustrated book fully reveals the role of pictorial representation as a means of communication independent of the written word and as a 'text' in its own right.

There were several phases involved in preparing a parchment manuscript. Before the text could be copied, the sheets had to be ruled: in other words, lines were drawn in order to guide the hand in writing, mark the space designated for the text and divide the space between text and commentary. Parchment was generally ruled by tracing a line with a wooden stick or metal implement that sometimes left a mark on several leaves at once. However, it could also be done with lead or ink, a practice normally used on paper. In turn, ruling was guided by a series of small holes made on the leaf—almost always along the margins—at an even distance using a notched wheel or, in some cases, a specific *tabula ad rigandum*. The procedures that were employed for ruling (leaf by leaf or a certain number of leaves at a time) and the type of ruling (the pattern formed by the marked lines) varied extensively. They have been classified and are normally indicated using a sequence of figures and letters that refer to the number, position and length of the lines, making it possible to understand how the page was constructed.

Transcription of the text was the next step. If a decoration and/or illustration was added, identification of the hands and techniques involved poses complex problems that must be investigated on a case-by-case basis. Once the work was completed, the quires were assembled and bound, using techniques that could vary according to the period or area. Conventional bindings were composed of wooden boards covered with leather and fitted with brass studs and clasps. Valuable bindings also existed (made of ivory, silver and, in some cases, studded with gemstones), but they were used chiefly for sumptuous codices containing sacred texts.

In codices the text was arranged in a full-page layout or in two or more columns. As far as script is concerned, in the Greek world various types of majuscule were used until the 8th and 9th centuries. Some of the most typical were the severe-style script, the biblical majuscule, the Alexandrian majuscule and the upright or sloping pointed majuscule. Between the 8th and 9th centuries the minuscule was also adopted, likewise in various styles according to the period and geographic area. The types that were used most widely until the 15th century—and, in some cases, also later—include the Philosophical Collection minuscule, the Anastasius-type minuscule, the *bouletée*, the pearl script, the *Fettaugenmode*, the mimetic minuscule, the Hodegon-style minuscule and, particularly in Greek-speaking southern Italy, the script referred to as *en as de pique*, the small round hand named after St Nilus and his followers, and the styles associated with Rossano and Reggio (Calabria), and Terra d'Otranto (Puglia). In the Latin world, minuscule scripts and mixed ones using both majuscule and minuscule forms, such as uncial and half-uncial scripts, began to emerge in the 2nd–3rd century AD, alongside the majuscule, or 'capital', that had already been employed for some time. A series of national and local scripts —the insular, Visigothic, Merovingian, Rhaetian, Germanic and Beneventan minuscules—developed during the Middle Ages, but they were all replaced at some point by the Caroline minuscule, that came to predominate between the 9th and 11th centuries. In the late 11th century the Caroline minuscule became increasingly rigid, subsequently developing into Gothic script, which spread throughout medieval Europe between the 12th and 13th centuries. Variants of Gothic script and types that adapted document or cursive forms for use as book-hands ultimately overlapped and, with the advent of Humanism, a new type of script emerged in Florence in the early 15th century. Inspired by ancient Caroline manuscripts, humanistic script appeared in the *rotunda* and *cursiva* styles.

Scriptio continua, adopted during the Graeco-Roman period, was used for centuries in Byzantium, where the sense of the text was conveyed by reading it aloud. In the Latin West, where silent reading predominated, spacing began to be used towards the 7th century, initially separating small groups of words, followed by sen-

tences and then words, in order to improve readability. Punctuation systems are documented in both Greek and Latin manuscripts, although they vary temporally and in terms of practice. Large initials, special scripts for titles and subtitles, and ornamentation—sometimes emphasized by inks or pigments in various colours— often appeared in manuscripts to separate the different books comprising a work or to divide several works within the same manuscript. The systematic use of auxiliary devices to facilitate reading and consultation developed starting in the 13th century, particularly in the West, e.g. division of the work into chapters and paragraphs, the use of titles—often penned in red—for the individual chapters, the distinction between major and minor initials, systems for linking comments to the main text, and indices.

A manuscript could also be the work of more than one scribe. In both the Greek Byzantine and Western Latin traditions there are numerous codices that bear subscriptions, commonly indicating the name of the scribe and sometimes also the date and place the book was copied. However, most extant books are not signed, nor is there any indication of the date or place they were copied. In some cases, examination of the script makes it possible to identify the hand, if it is already known from other manuscripts, or distinguish among the different hands if several scribes were involved. Furthermore, it permits approximate dating of the book and sometimes helps determine where it was produced.

The copy of a manuscript book was generally made from a single exemplar or source, but there were cases in which the scribe used several exemplars, choosing from the different readings they offered or citing them as alternative readings (*variae lectiones*). In other cases the exemplar contained interlinear or marginal variants that the scribe copied into his own work or from which he would choose. In the textual tradition, these cases are referred to as 'contamination'.

During copying, above all when the text was transferred from one script to another, mistakes could occur if the exemplar was misread or the scribe misunderstood the text. Nevertheless, not all manuscript errors can be attributed to misreading, because in many cases they were due to distraction on the part of the scribe or were even made intentionally to alter the text. Inaccuracies also arose due to aural rather than visual misunderstandings, not only with texts written under dictation, as was sometimes the case, but also when the copyist read a phrase and then spoke it aloud as he transcribed it.

In any event, given the fact that—for a number of reasons—copying almost invariably engendered mistakes, as early as classical times the copies were revised and corrected (*emendatio*), generally by comparing them to the exemplar. In Late Antiquity this work, which was originally performed by the scribe himself or by a pro-

fessional corrector (*diorthotes*, *emendator*), also became the intellectual undertaking of educated individuals, teachers and students. A large number of subscriptions of extant classical and Christian texts from this period show that *emendatio* was used extensively. This practice continued in both the Greek and Latin Middle Ages, with a vigorous revival under the Palaeologi (1261–1453) in the East and during Humanism in the West.

The production of manuscript books varied in different eras and sociocultural contexts. During the Graeco-Roman period, manuscripts were produced by professional scribes who oversaw workshops and made bespoke copies or books intended for sale, by slaves who worked in the homes of the wealthy, or by the readers themselves, i.e. individuals who could write and were interested in specific texts; some were also produced by *librarii* at public libraries. The changes in society and culture between antiquity and the Middle Ages also brought about changes in the way manuscript books were produced, and there were differences between the Byzantine and the Latin Middle Ages. In the Greek East, throughout the Middle Ages manuscripts were produced by workshops or individuals—laypeople, monks or clergymen—who copied books for patrons, by whom they were paid, or for themselves. Copying was done at several monasteries, but as a rule it was the work of individual monks rather than a community effort. In scholarly circles, manuscripts were often produced by several scribes working together. Thus, copying was done in a number of different places: bookmaking workshops; monasteries such as the Studion and the Hodegon in Constantinople, the monasteries of Great Lavra and Vatopedi on Mount Athos, and the monastery of St John the Theologian on the island of Patmos; the homes of professional scribes or scholars; schools; and the imperial palace. As far as the Latin West is concerned, a distinction must be made between the early and late Middle Ages. Although there were also itinerant scribes and independent copyists, most manuscript books in the early Middle Ages, between approximately the 7th and 11th centuries, were produced by scriptoria annexed to monasteries and episcopal sees. The scriptorium was essentially a room—spacious in some monasteries, cramped in others—in which books were made and copied, and it was furnished with a worktable in the middle and the scribes' desks arranged along the windowed outer walls. Copying was painstaking work and sometimes the scribe noted his efforts in the subscription. We often read that copying work ruined the scribe's eyesight, caused backache and, despite the fact that only three fingers were used to write, racked and fatigued his entire body. It is important to note that the monastic or episcopal scriptorium was a community area that was perfectly organized for the production of books. There were famous medieval scriptoria at the episcopal sees of Freising, Vercelli and Verona; at monasteries in the British Isles and

GUGLIELMO CAVALLO

in Northern Europe, such as Wearmouth–Jarrow, Corvey, Hersfeld, Fulda, Lorsch, Corbie and Reims; further south at Reichenau, Murbach, Auxerre, Fleury, Tours, Luxeuil, Saint Gall and Cluny; and in Italy at Nonantola, Bobbio, Farfa and Montecassino. The establishment of the mendicant orders (Franciscans and Dominicans) in the late Middle Ages marked the demise of the scriptorium, although in some instances scribes continued to work at convents and monasteries. Nevertheless, by the late 14th century and particularly in the 15th century books began to be produced by lay artisans at their workshops and by scribes, sometimes itinerant, who—in growing numbers—worked in cities to meet the pressing demand for books among new and broader readerships. Some of them were stationers and book merchants such as the famous Florentine Vespasiano da Bisticci, who attracted skilled professional scribes and famous illuminators who have been credited with producing some of the most elegant and exquisite books of the humanist era.

The manuscript—initially in roll and then in codex form—was the vehicle for transcribing, transmitting and preserving texts from antiquity to the Renaissance. Consequently, it is thanks to manuscript books that Greek and Latin, classical and Christian literature, not to mention books in the vulgar tongue and vernacularizations, have been handed down to the modern age. Indeed, the models and transformations of the manuscript, which in turn were connected to the overall history of culture and society, marked the 'key' moments in textual transmission.

The first significant step was the transition from roll to codex. Since the latter could hold larger amounts of text, this made it possible to contain works composed of several books in a small number of codices, create bodies of writings by a single author, and compile miscellaneous manuscripts containing various types of texts. Furthermore, the codex format profoundly influenced the relationship between text and commentary. During the era of rolls, commentaries were written on separate rolls and referenced through a system of symbols. In codices, however, large margins could be left around the text so that comments could be included on the same page. In classical texts these annotations, or scholia, were drawn mainly from older commentaries, whereas for biblical works comments extracted from patristic works, arranged in the form of *catenae*, were used. Moreover, the codex format allowed readers to add marginal or interlinear notes as they went along, due to the fact that, while rolls had to be held in both hands, codices could be read with just one hand or set on a bookstand.

Another important step in the history of the manuscript and textual tradition was marked by the post-iconoclastic period and the Macedonian renaissance in the Greek East, and by the Carolingian renaissance in the Latin West. Towards the early 9th century the minuscule script was adopted as a book-hand in Byzantium and,

from this point on, texts underwent a process referred to as 'transliteration', meaning that they were transcribed from majuscule to minuscule, which led to the creation of an entirely new type of Greek manuscript. In the 9th and 10th centuries Constantinople, the metropolis of the Byzantine Empire, was one of the leading centres for the production of books and it seems that this work was done by scholars as well as lay scribes, monks and clergymen. In medieval Europe, Caroline minuscule was the hand adopted between the late 8th and the late 9th century for the new Latin book, which replaced older capital, uncial and half-uncial manuscripts. During this period, which marked the height of the Carolingian renaissance, numerous manuscripts were produced—above all in Italy, France and Germany—not only at monastic and episcopal scriptoria but, in some cases, also at courts or by lay scribes.

The structure of the manuscript changed once more in the East between the 13th and 14th centuries, when the 'scholarly' manuscript came to predominate, and in the West during the humanist period with the manuscript of this new culture. Nevertheless, the invention of the printing press and the spread of printed books in the 15th century did not immediately lead to the demise of the manuscript book, which continued to circulate for some time alongside printed editions. There are even manuscripts that are detailed reproductions of printed books!

Our discussion here has revolved around books and written culture in the ancient world, and in the Greek East and the Latin West during the Middle Ages. And yet if we examine other ancient and medieval book cultures, for example those of the Middle and Far East, we find that there is always a constant: regardless of the area, the two main book formats—in some cases coexisting for even longer periods with respect to the Greek and Roman traditions—are the roll and the codex.

ESSENTIAL BIBLIOGRAPHY

La paléographie grecque et byzantine, Proceedings of the International Symposium (Paris, 21–5 October 1974), introduction by J. Bompaire, J. Irigoin, Paris 1977.

E.G. Turner, *The Typology of the Early Codex*, Philadelphia, Penn. 1977.

E.G. Turner, *The Terms Recto and Verso. The Anatomy of the Papyrus Roll* [= *Actes du XVᵉ Congrès international de papyrologie. I* (Brussels–Louvain, 29 August–3 September 1977), edited by J. Bingen and G. Nachtergael], Brussels 1978.

Libri, scrittura e pubblico nel Rinascimento. Guida storica e critica, edited by A. Petrucci, Rome–Bari 1979.

B. Bischoff, *Paläographie des römischen Altertums und des abendländischen Mittelalters*, 2nd revised edition, Berlin 1986 (1st edition 1979); English edition *Latin Palaeography: Antiquity and the Middle Ages*, translated by D. ó Cróinín and D. Ganz, Cambridge 1990.

Les débuts du codex, Proceedings of the Colloquium organized in Paris, 3–4 July 1985, by the Institut de Papyrologie de la Sorbonne and the Institut de Recherche et d'Histoire des Textes, edited by A. Blanchard, Turnhout 1989.

L.D. Reynolds, N.G. Wilson, *Scribes and Scholars. A Guide to the Transmission of Greek and Latin Literature*, 3rd edition, Oxford 1991 (1st edition 1968).

J.J.G. Alexander, *Medieval Illuminators and Their Methods of Work*, New Haven–London 1992.

M. Capasso, *Volumen. Aspetti della tipologia del rotolo librario antico*, Naples 1995.

A. Petrucci, *Writers and Readers in Medieval Italy. Studies in the History of Written Culture*, edited by Ch.M. Radding, New Haven–London 1995; Italian edition *Scrivere e leggere nell'Italia medievale*, edited by Ch.M. Radding, Milan 2007.

Scrivere libri e documenti nel mondo antico. Mostra di papiri della Biblioteca Medicea Laurenziana, exhibition catalogue (Florence, Biblioteca Medicea Laurenziana, 1998), edited by G. Cavallo *et al.*, Florence 1998.

G. Cavallo, *Dalla parte del libro. Storie di trasmissione dei classici*, Urbino 2002.

M. Maniaci, *Archeologia del manoscritto. Metodi, problemi, bibliografia recente*, with essays by C. Federici and E. Ornato, Rome 2002.

E. Crisci, 'Papiro e pergamena nella produzione libraria in Oriente fra IV e VIII secolo d.C. Materiali e riflessioni', *Segno e testo*, 1 (2003), 79–127.

L. Del Corso, 'Materiali per una protostoria del libro e delle pratiche di lettura nel mondo greco', *Segno e testo*, 1 (2003), 5–78.

F. Ronconi, *La traslitterazione dei testi greci. Una ricerca tra paleografia e filologia*, preface by G. Cavallo, Spoleto 2003.

W.A. Johnson, *Bookrolls and Scribes in Oxyrhynchus*, Toronto–Buffalo–London 2004.

Libri, editori e pubblico nel mondo antico. Guida storica e critica, 4th revised edition, edited by G. Cavallo, Rome–Bari 2004 (1st edition 1975).

G. Cavallo, *Il calamo e il papiro. La scrittura greca dall'età ellenistica ai primi secoli di Bisanzio*, Florence 2005.

Lire le manuscrit médiéval. Observer et décrire, edited by P. Géhin, Paris 2005.

M. Caroli, *Il titolo iniziale nel rotolo librario greco-egizio, con un catalogo delle testimonianze iconografiche greche e di area vesuviana*, Bari 2007.

H. Ishøy, 'Parchment as a Writing Material in the Late Republic and the Early Empire', *Classica et Mediaevalia*, 58 (2007), 259–83.

THE PAPYRUS COLLECTION

by ROSARIO PINTAUDI

1. PSI XIII 1300

11 × 14.5 cm
2nd century BC

First published in June 1937 by Medea Norsa, a scholar who worked with Girolamo Vitelli, the ostracon from the 2nd century BC is inscribed with several strophes from one of Sappho's odes (fr. 2 Lobel–Page). The text was probably copied by a pupil under dictation. In works ranging from Norsa's *editio princeps* to Franco Ferrari's recent contributions (2001), generations of scholars have attempted to interpret the lines that have fortunately been preserved on this extremely fragile writing material.

2. PSI III 275

11 × 8.5 cm
Thebes, 28 June 151 AD

3. PSI III 276

12 × 9 cm
Thebes, 11 July 151 AD

4. PSI III 277

9.5 × 7 cm
Thebes, 31 July 152 AD

Ostraca with receipts issued by the public granary.

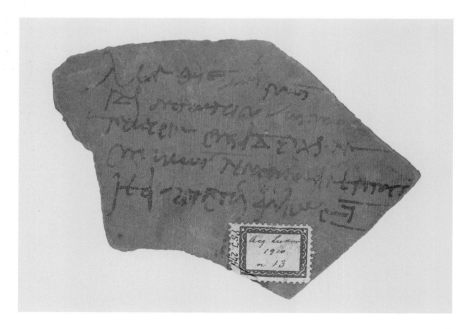

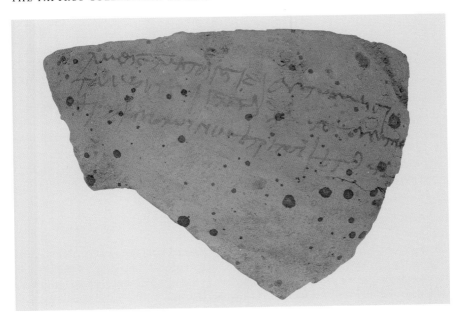

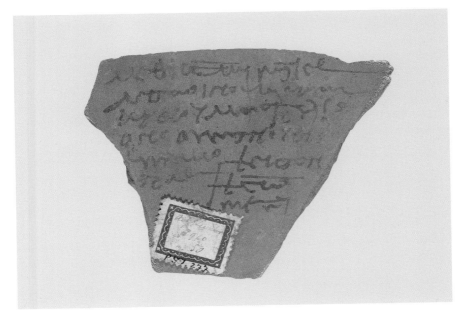

5. PSI IX 1027

18 × 13.5 cm
Ptolemais Euergetis, AD 151

This is a wax tablet (the wax has characteristically turned black) from Ptolemais Euergetis, a city in the Arsinoite nome (district). It is the last part of a set containing a will written in Latin, according to the principles of Roman law. In this text, Herennia Helene accepts the inheritance left to her by her father, L. Herennius Ualens.

6. PL III/973

25 × 13 cm
6th–7th century AD

The last tablet from a polyptych, the rest of which has been lost. In the 6th–7th century AD someone—possibly a schoolteacher—used its now-waxless surface to write a Coptic alphabet, a script adapting the Greek alphabet to the Egyptian language, with the addition of seven demotic signs.

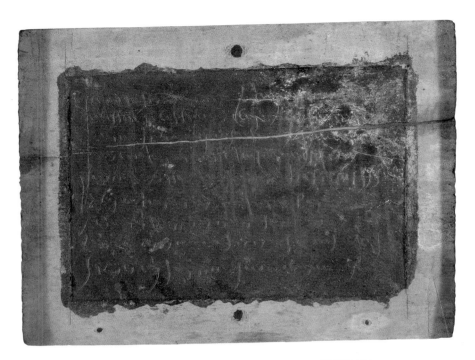

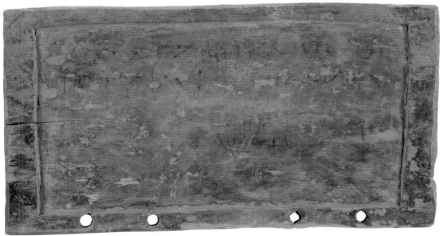

7. PSI I 28

18 × 20 cm
Hermopolis Magna, 3rd–4th century AD

Lead tablet with a magic text in Greek; based on the script, it can be dated to the 3rd–4th century AD. The text invokes a deity that incorporates the attributes of Artemis-Hecate and Persephone. It may have been a love charm.

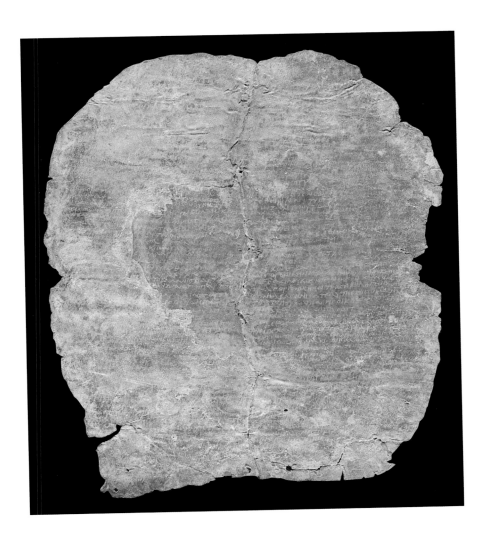

8. PSI I 103

11 × 22 cm
Mendes, 3rd century AD

The only papyri that have survived from the wetlands of the Nile Delta are carbonized rolls. When a fire broke out in public archives, the carbonization process preserved the administrative rolls, which Egyptian merchants subsequently cut and glued to boards. As a result, they are now part of some of the most important Western papyrus collections. This papyrus contains an official's report on taxes collected from villages.

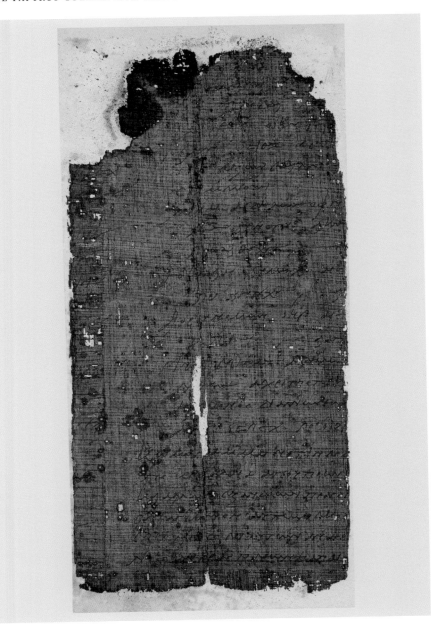

9. PSI V 514

31.5 × 25 cm
Philadelphia, 24 April 251 BC

The *dioiketes* Apollonios (finance minister of King Ptolemy II Philadelphus), in Alexandria, wrote a letter to Zenon, the administrator of his vast farming estate in Philadelphia, demanding that, within three days, he send to the capital city the offering that the community of Philadelphia was required to contribute for the *stephanephoria* ceremony honouring the king. Immediately afterwards Zenon was to arrange to send what had been ordered to honour the anniversary of the king's ascent to the throne.

The papyrus is part of the enormous Zenon Archive, whose documents have made it possible to reconstruct the life of this figure. Born in Caunus, on the coast of Asia Minor, he went to work for Apollonios in the autumn of 261 BC. After serving in Palestine, he returned to Egypt; in the summer of 258 he began to accompany Apollonios on his journeys, working as his private secretary. According to the documents, in April–May 256 he was sent to Apollonios' estate near Philadelphia, which he oversaw until 248/7. Zenon left this position in 247 but remained in the countryside, living on the income he earned from his vineyards and flocks, and from leasing his land. We do not know when he died, but he is last mentioned in a document dated 14 February 229.

The 353 Florentine papyri from the Zenon Archive, written in Greek with the exception of a few demotic and Greek-demotic documents, were originally purchased by Guido Gentilli and were then progressively acquired by the Biblioteca Medicea Laurenziana starting in January 1917.

10. PSI IV 361

34.5 × 34 cm
Philadelphia, 7 December 251 BC

In this letter the nomarch Maimachos informs Zenon that he has assigned grazing land to Kallippos and Amortaios, as Zenon had requested. Furthermore, he asks him to intercede with the official Diotimos on his behalf in order to regain the latter's esteem. Maimachos also informs him that he has written a letter to Diotimos, beseeching Zenon to deliver the letter to the official and offering his children's services in exchange. Maimachos also has another request to make: Zenon can help him by writing a letter of recommendation to Aristandros, treasurer of the Arsinoite nome.

Zenon evidently agreed to the latter request, since the draft of the letter to Aristandros is on the verso of the papyrus.

11. PSI IV 422

15.5 × 35 cm
Philadelphia, mid 3rd century BC

Psentaes complains to Zenon that he was unable to plough the land at the right time and, as a result, it is full of gullies. Nevertheless, this was not due to an oversight on his part but was the fault of the person who was supposed to provide him with pairs of oxen: not only did he give him an insufficient number, but he also did not bring them when they were needed. Psentaes thus asks Zenon to make arrangements to provide him with the animals he needs to prove that he can work skilfully and quickly.

12. PSI IV 428

65 × 12.5 cm
Philadelphia, undated (but probably before December 260 BC)

The papyrus (pages 40–1, top) is part of the Zenon Archive and is broken off on the left. It is an account of foodstuffs, including wine, oil, honey, garlic, salted fish and nuts.

13. P. Flor. II 148

20.5 × 19.5 cm
Theadelphia, AD 265–6

The Heroninos Archive, one of the largest from the Roman period, is divided between the Prague and Florence collections. More than 1000 texts from the mid 3rd century AD—accounts and letters—describe the agricultural activities of farms connected with large estates.

The text in P. Flor. II 148 (pages 40–1, bottom: left, the recto; right, the verso) gives the farmer Heroninos instructions on layering vines.

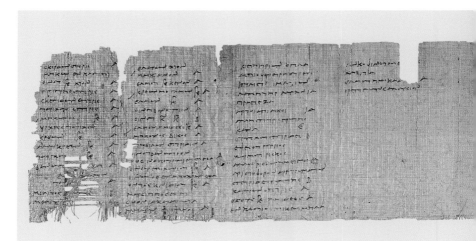

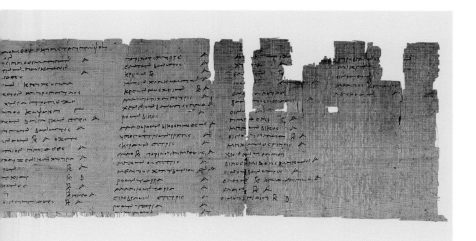

14. P. Flor. I 93

35.5 × 32.5 cm
Antinoë, AD 569

The archive of Dioscorus of Aphrodito is one the most important sources of information about Egypt during the reigns of Justin I, Justinian and Justin II. It covers the period from the beginning to the last quarter of the 6th century AD.

Dioscorus, a notary, wrote the text in P. Flor. I 93, a divorce contract; its clauses respect the notarial practices of the time to the letter.

15. PSI XII 1266

34.8 × 30.7 cm
Apollonopolis, AD 675/6 or 660/1

The papyrus, a fragment of which is preserved in Cairo, is from the archive of Papas, pagarch of Apollonopolis (Edfu). His pagarchy (a geographic-administrative unit in Late Byzantine/early Arab Egypt) was subject to the duke of the Thebaid, which was represented by one of his lieutenants when the duke was away from Antinoë, the capital city. This letter was sent to Papas by the lieutenant.

Caulkers, forced labourers sent from various districts to the shipyards of Babylon (Fustat–Cairo) to waterproof boat hulls, faced such harsh working conditions that they escaped, returning to their villages or fleeing to other pagarchies. According to the circular, the pagarchs were not to let a single caulker from their district get away or they would be forced to pay 1000 *solidi* and possibly face the death penalty. The pagarchs were required to capture the men and confine them to prison boats, where they would serve their sentences. Furthermore, if they captured caulkers from other districts, they were to send them to Antinoë in irons.

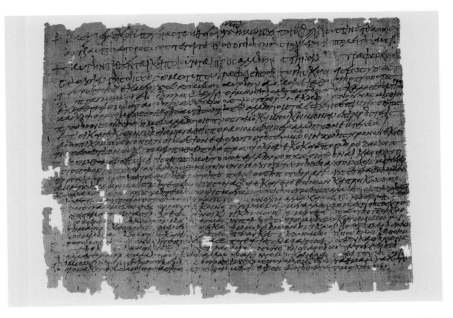

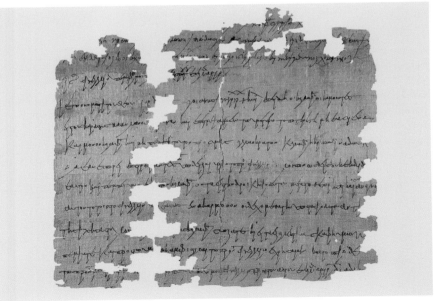

16. PSI X 1197

A: 6.8 × 13 cm
B: 26.5 × 21 cm
C: 8.8 × 11.5 cm
Oxyrhynchos, end of the 1st century–mid 2nd century AD

The remains of two deluxe *volumina*—for library consultation rather than scholastic use—were part of a single edition of Xenophon's *Hellenica*. Of the three fragments, A and B are from Book V and, therefore, the same *volumen*. Fragment C is from Book VI and may thus be from another *volumen*, but it was written by the same hand.

17. P. Flor. I 71

28 × 28 cm
Hermopolis Magna, 4th century AD

This land register in the form of a booklet—resembling a codex—is from Hermopolis Magna and is datable to the 4th century AD. Names, acreages, figures and crop yields make this document, which is unique because of its completeness and wealth of information, even more fascinating.

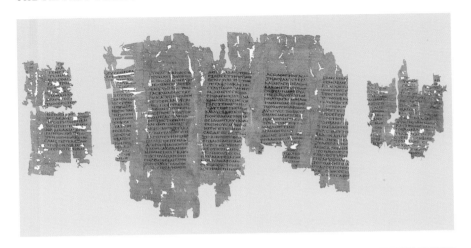

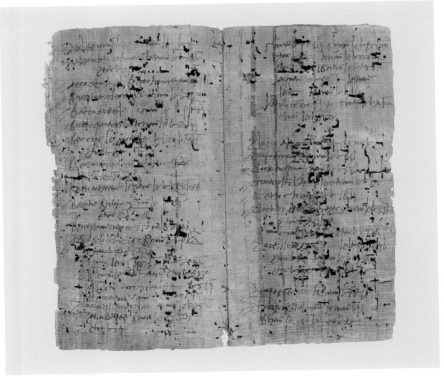

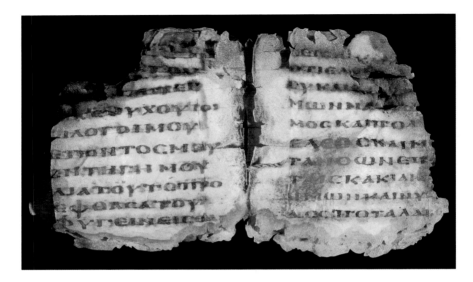

18. PSI X 1164

5 × 6.5 cm
4th century AD

This small and elegant parchment codex consists of two quires and a sheet. The 24 pages contain virtually the entire text of the four chapters of the Book of Jonas (Old Testament).

19. PSI XIV 1371

19 × 27.5 cm
mid 5th century AD

Sheet from a papyrus codex with Psalm 36.5–24 written on 27 lines on the recto and 26 on the verso. The same hand that wrote the text also numbered the pages (23 recto—opposite—and 24 verso).

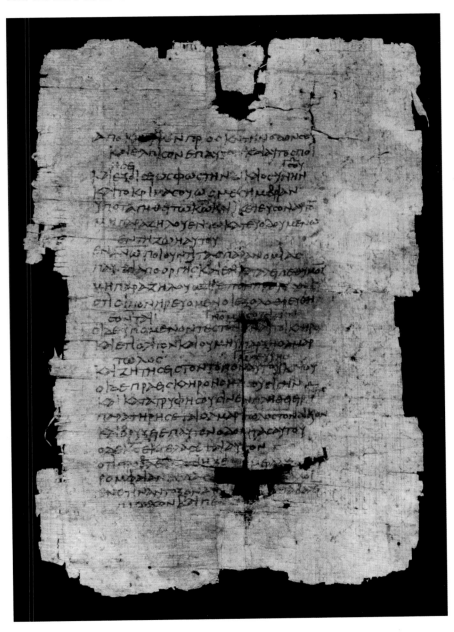

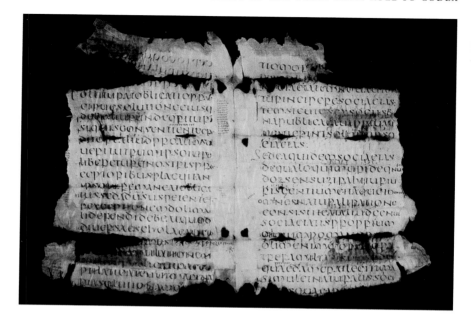

20. PSI XI 1182

16 × 20 cm
Antinoë?, 4th century AD

The two parchment sheets, possibly from Antinoë and dating to the 4th century AD, are fragments from a deluxe Latin codex with the remains of Gaius' *Institutiones* (2nd century AD). The Latin text is accompanied by glosses in Greek. It is one of the oldest and most valuable witnesses of this work by the illustrious jurist.

ESSENTIAL BIBLIOGRAPHY
Papiri greci e latini 1912–; *I papiri dell'archivio di Zenon* 1993; *Gli archivi della memoria* 1996; *Scrivere libri e documenti* 1998.

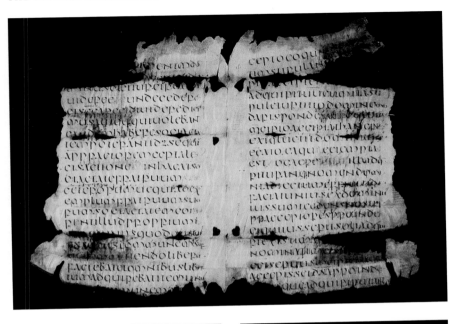

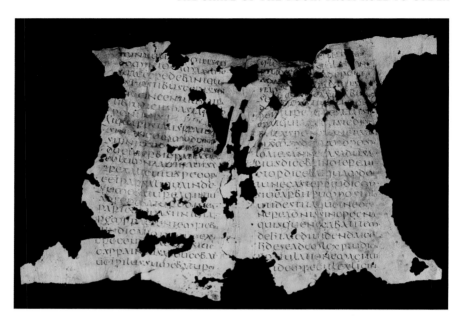

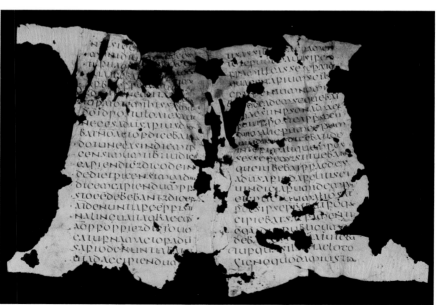

THE MANUSCRIPT COLLECTION

Entry authors

E.A. Eugenia Antonucci
F.A. Franca Arduini
S.M. Sabina Magrini
I.G.R. Ida Giovanna Rao

21. The Acts of the Apostles

Constantinople, 11th century
parchment; 175 × 150 mm
Pluteo 4.31

The manuscript, with a text from the New Testament copied in Greek minuscule book-hand, is an example of the virtually square format (175 × 150 mm; w/h ratio = 0.857) that distinguished many Greek codices from Late Antiquity.

[I.G.R.]

22. Guillaume de Lorris and Jean de Meung, *Le roman de la rose*

France, 14th century
parchment; 242 × 78 mm
Acquisti e Doni 153

This elegant example of the well-known allegorical poem is bound in a tall and narrow format (242 × 78 mm; w/h ratio = 0.330) that was common from the 11th to the early 13th century, and was used mainly, although not exclusively, for Latin poetry.

[I.G.R.]

23. Livy, *Ab urbe condita* (Books XXI–XXX)

Florence, 15th century (1463)
parchment; 330 × 225 mm
Edili 182

This classic humanistic codex was copied and subscribed in 1463 by "Anastasius ser Amerigi de Vespucijs", father of the better-known Amerigo Vespucci. It illustrates the average manuscript format (330 × 225 mm; w/h ratio = 0.681) and reflects the so-called 'invariant proportion' (ranging from 0.613 to 0.717).

[I.G.R.]

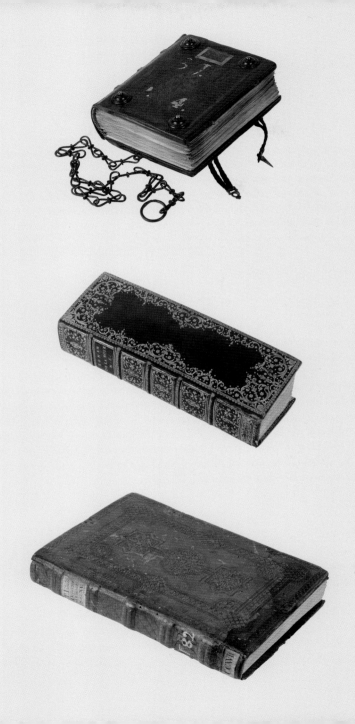

24. Prayer book and almanac

16th century
paper; 79 × 51 mm
Pluteo 2.16

The manuscript is an example of a typical prayer book for personal use, as it was compact and thus easy to carry. It contains the *Seder Tefillot*, or the order of prayers to be recited throughout the year, and was bound together with a *Tabella cursus lunaris* for the year 1567. The need for a handy reference for determining the phases of the moon, and thus religious holidays and hours of prayer, explains the combination of these two texts. The Medici binding and chain were added later.

[S.M.]

Biscioni 1752–[7], 75; Bandini, ed. 1990, 99 note 54.

25. The Book of Esther

Italy, 18th century
parchment; 180 × 3180 mm
Acquisti e Doni 801

The parchment roll is attached to a boxwood rod in order to make it easier to read (from right to left). The text, written in Sephardic script, reflects the traditional arrangement in 21-line columns. It contains the Book of Esther, which—along with the Song of Solomon, the Book of Ruth, the Lamentations and Qohelet (Ecclesiastes)—is one of the five scriptural texts (*Megillot*) traditionally read during certain festivals. On Purim (Feast of Lots), which originated from the story of Esther, this roll is read twice: on the eve of Purim and on the holiday itself. The Library acquired this roll in 1982.

[S.M.]

26. Magical texts

19th–20th century
parchment; 1982 × 117 mm
Acquisti e Doni 821

The manuscript is an interesting example of an Ethiopian magic scroll. This vertical scroll —the characteristic format for this type of book—is composed of four parchment membranes sewn together with strips of leather. It is written in a calligraphic hand in a single column, which was read from top to bottom. It contains various drawings as well as prayers

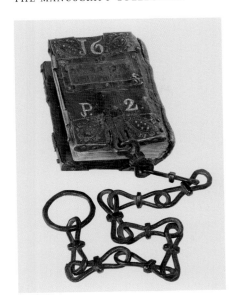

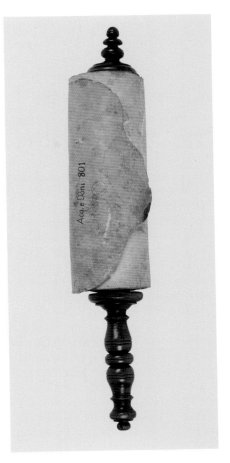

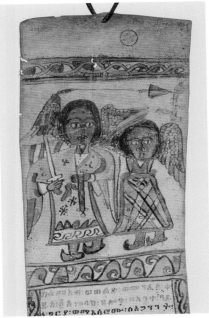

to bind and swallow demons, and as protection against the evil eye, as well as magical names, the first lines of the Gospel of John, and an invocation to God. The Library acquired this scroll in 1985.

[S.M.]

Marrassini 1987, 102–5.

27. Cicero, philosophical miscellany

France (Corbie), second half of the 9th century
parchment; 315 × 265 mm; fols. iv (i–ii paper) + 90 + iii (paper)
San Marco 257

This composite codex (fols. 1–40; 41–90) holds an anthology of Cicero's works (*De natura deorum, De divinatione, Timaeus, De fato, Topica, Paradoxa Stoicorum, Academica II, Lucullus, De legibus*) written in Caroline script at the flourishing scriptorium of the French abbey of Corbie and assembled no later than the 10th century. As indicated on fol. 1r—"Werinharius episcopus dedit Sanctae Mariae"—it belonged to Werinharius II, the bishop of Strasbourg (1001–28), who gave it to the city cathedral, where it was discovered and purchased by Poggio Bracciolini (1380–1459) in approximately 1417–8. It was subsequently acquired by Niccolò Niccoli (*c.* 1364–1437) and was listed as no. 178 in his inventory. Following the humanist's death, it was bequeathed to the library of the Dominicans of San Marco, where it became part of the "XXIII° banco ex parte occidentis". It was during this period that Politian (Angelo Poliziano, 1454–94) collated this text of *De natura deorum* and *De divinatione* against the 1471 Venetian edition of Wendelin of Speyer (GW 6902; IGI 2878). It was transferred to the Biblioteca Laurenziana, where it is conserved today, following Napoleon's suppression of convents and monasteries in 1809.

Only two illuminations—purely ornamental—adorn the manuscript. One embellishes the letter *Q* (fol. 1r), which has two lateral medallions framing unidentifiable portraits; the letter is set beneath a round arch sustained by columns with Corinthian capitals in the Eusebian style. The other decorates the letter *M* (fol. 51va) at the beginning of the *Timaeus*. Both of them reflect the general insular influence that distinguished the work produced by the Corbie scriptorium also on a graphic level.

The manuscript is open at fol. 1r, with the incipit of Cicero's *De natura deorum*.

[I.G.R.]

Index 1768, 142; Ullman–Stadter 1972, 31, 66, 89, 225, no. 862, 287, no. M289; *Marsilio Ficino* 1999, 65–6, no. XI; *La biblioteca di Michelozzo* 2000, 126, no. 18.

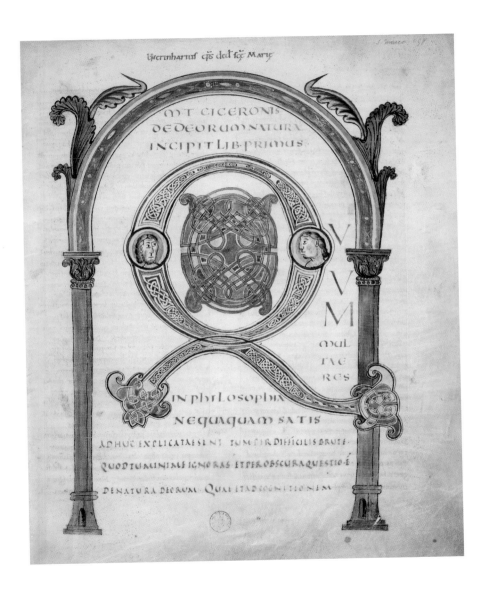

28. Medical miscellany

Constantinople, beginning of the 10th century
parchment; 370 × 280 mm; fols. iv (i–iii paper) + 408 + iii (paper)
Pluteo 74.7

This famous codex, written in minuscule in two columns by the physician Nicetas (9th–10th century) and thought to have been produced by the imperial scriptorium during the reign of Constantine VII Porphyrogenitus (905–59), unites the medical works of various Greek writers (Hippocrates, Galen, Oribasius, Heliodorus, Archigenes, Antyllus, Asclepiades, Diocles, Amyntas, Apollonius of Citium, Nymphodorus, Apelles, Rufus of Ephesus, Soranus, Paulus Aegineta and Palladius). The collection is preceded by a table of contents (fols. 2r–7v) and three epigrams (fols. 8v, 9r, 9v), considered autographic, which credit Nicetas with having discovered and assembled these ancient medical texts.

Conserved at the hospital annexed to the church of the Forty Martyrs in Constantinople, as indicated in an ownership inscription (fol. 407v), the manuscript was then acquired by the humanist Janus Lascaris (1445–1535) during his second trip to Greece (1492) on behalf of Lorenzo de' Medici (1449–92) and it became part of the private library as "n° 231", indicated on fols. 2r and 10r of the codex.

Two of the works rediscovered by the Byzantine physician—and for some of them the Laurentian manuscript is the only witness—are illustrated. The first (fols. 180va–227rb) is Περὶ ἄρθρων by Apollonius of Citium (1st century BC), discussing the reduction of bone fractures; the second (fols. 228ra–40va) is Περὶ ἐπιδέσμων by Soranus of Ephesus (2nd century AD), explaining and illustrating the broad range of possible bandages.

The manuscript is open at fols. 196v–7r, with two examples of how to set hand fractures.

[I.G.R.]

Bandini 1764–70, III, cols. 53–93; Vogel 1854, 159; Piccolomini 1874–5, 15, 24; *Biblioteca Medicea* 1986, 92, plates XXIII–XXIV; *I luoghi della memoria* 1994, 139, no. 10.

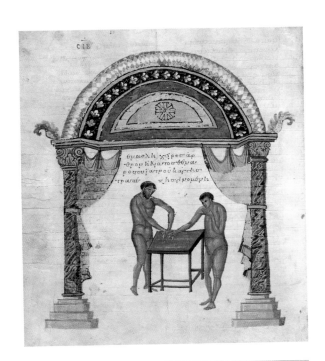

σμιολὴ χειροσ ἀπ
θρομ ἡ δι ἀπ τοῦ θθμα
ρου τοῦ ἰατροῦ ἱμ· τὸ
τραγαβ κ̇ λοι τρομβλτλ·

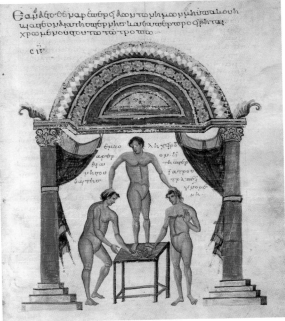

Θ αμ δ ϲο θϲ μαρ εωθρ ολ ἐωντο λημ ομ μικ ῦ σαλιουκ
ιμα εϲο μδμη ικτ ῦ ϲ ορμηϲ ια τα πα τε τρο ρο θρκ τα·
χρω μεμου ϲουτ ω τω τρο πω·

σμιο λὴ χειρὸ λ ἡ χ φο
αρθρ ορ· τ
δια τη αφρ
μη του ϲ ιατρου
ια τ τῦ ν τρ λα δι
 γ ι ρομ
 βλ ὴ

29. Pliny the Elder, *Naturalis Historia* (Books I–XVI)

Northern Europe, beginning of the 13th century
parchment; 405 × 305 mm; fols. i + 166 + i
Pluteo 82.1

In terms of its materials, script and ornamentation, this codex is a typical example of the high-quality manuscript production of northern Europe and it can be dated to the early 13th century. The first of two volumes (the second is Plut. 82.2, containing Books XVII–XXVII of the *Naturalis Historia*), the manuscript is written in *littera textualis* and is distinguished by its rich ornamentation, which includes the large scene (fol. 2v) portraying Pliny as he offers his work to the emperor Titus, initials whose decorative repertory reflect insular influences, and figured initials. As Giovanna Lazzi noted (*Vedere i classici* 1996), for the latter it seems that the illuminator took up "an established repertory, but one that is unrelated to the text". Indeed, these initials draw on liturgical and religious models: for example, the Christ in Majesty in the letter *O* (fol. 141v) and the Nativity in the letter *P* (fol. 147v).

The small figure depicted in the scene at fol. 2v, set amidst the foliage of a tree and bearing a cartouche with the words "Petrus de Slaglosia me fecit", has been identified as the illuminator of this codex, who may have been from Slagelse, Denmark. Studies conducted by Filippo Di Benedetto (1972) have confirmed that in the 15th century the two volumes, Plut. 82.1 and 82.2, were at a Dominican convent in Lübeck, where they were 'discovered' by Ludovico Baglioni. Between 1413 and 1433 Baglioni was the partner of Gherardo Bueri (*c.* 1386–1449), a distant relative of the Medici family and head of the Lübeck branch of the Medici bank. Baglioni informed Cosimo de' Medici the Elder (1389–1464) of the existence of the two manuscripts and, urged by Niccolò Niccoli (*c.* 1364–1437), Cosimo spared no effort to obtain them. He was ultimately successful and thus the first complete copy of Pliny's work was brought to Florence. The codices became part of the library of the convent of San Marco and were then transferred to the Biblioteca Laurenziana, probably at the behest of Grand Duke Cosimo I.

This may have been the manuscript viewed by Julius Pomponius Laetus (1428–97; see Avesani 1962). It was methodically collated by Politian (1454–94), who taught a private course on Pliny between October 1489 and April 1490. Indeed, the *Naturalis Historia* was the focus of humanistic debate from both a philological and scientific standpoint (Charlet 2003).

The manuscript is open at fol. 2v, portraying the author dedicating his work to the emperor Titus.

[S.M.]

Bandini 1774–8, III, cols. 185–6; Avesani 1962, 82; Di Benedetto 1972, 437–55; *Firenze e la scoperta dell'America* 1992, 56–8; *I luoghi della memoria* 1994, 162–3; *Vedere i classici* 1996, 229–32; Charlet 2003, 20.

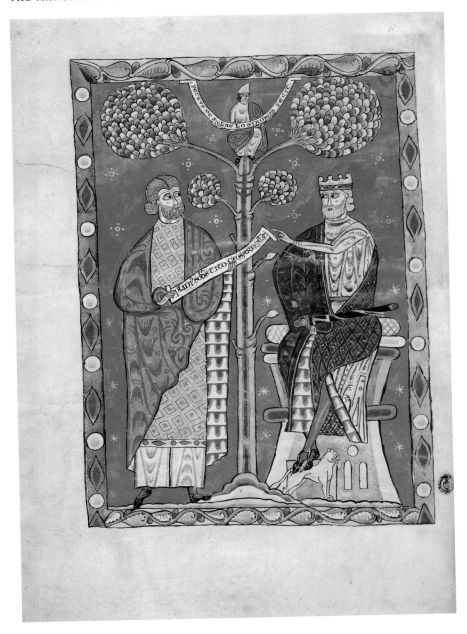

30. French miscellany

Northern France (Thérouanne?), beginning of the 14th century
parchment; 335 × 230 mm; fols. iv (i–iii paper) + 265 + iv (iii–iv paper)
Ashburnham 125

Written in *littera textualis* in two columns, the volume—which opens with two quires of in-dices penned in red—contains a collection of French texts, including Brunetto Latini's *Tre-sor* (fols. 16r–139r), the Pseudo-Turpin Chronicle (fols. 140r–54v), the *Book of the Seven Sages* (fols. 155v–183r), the translation of Giles of Rome's *De regimine principum* into vernacular French (fols. 187r–262v), attributed to "Henris de Gauchi" in the manuscript, and the pseu-do-Hippocratic letter *Regimen sanitatis (salutis) ad Cesarem* (fols. 266v–7r), which closes the volume. It is no accident that the miscellany contains Latini's *Tresor* and the political trea-tise by Giles of Rome—although there are other works between the two—given the fact that, in the manuscript tradition, *De regimine principum* is sometimes included in the third book of Latini's famous encyclopaedia, a book that is devoted not only to rhetoric but also to pol-itics. The juxtaposition—and effective fusion—of the two texts reflects an attempt to com-plement the political discourse offered by Latini's text and make it more universal, as it fo-cuses chiefly on 'Italian customs', notably communal institutions, while overlooking 'French customs' and the government of princes.

This sumptuous codex was produced in northern France (probably at Thérouanne). Its rich decoration, in which gold was used extensively, is composed of numerous miniatures, historiated and inhabited initials, and elaborate borders framing the text and occupying the intercolumnar space, with animals, human figures involved in various activities and satiri-cal scenes with grotesque characters (drolleries).

It belonged to "Anthoine Trudaine d'Amiens", as indicated in the ownership inscription (fol. 266v), and subsequently to the chancellor of France Henri-François d'Aguesseau (1668–1751), whose coat of arms with two fesses and six shells is tooled in gold on the boards of the binding. Once part of the Perrin de Sanson collection, which was sold in 1836, it was pur-chased by the bibliophile Guglielmo Libri in Paris. In 1847 Libri sold it and other manu-scripts from his collection to Bertram Ashburnham, 4th Earl of Ashburnham. The Bibliote-ca Laurenziana obtained it in 1884, when the Italian government purchased the Libri collec-tion from Lord Ashburnham's heirs.

The manuscript is open at fol. 16r, with the incipit of the *Tresor*.

[E.A.]

Relazione 1884, 13; *I codici Ashburnhamiani* 1887–1917, 75–8; *Mostra di codici romanzi* 1957, 62; Hunt 2007, 114–9 (with bibliography).

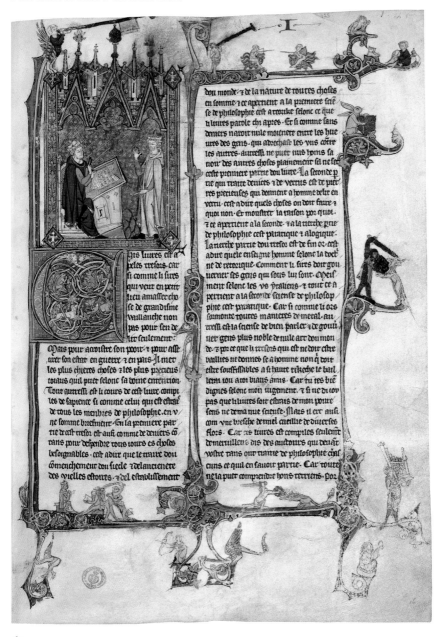

31. Bernard of Parma, *Glossa ordinaria in Decretales*

first half of the 14th century
parchment; 190 × 140 mm; fols. v (i–iii paper) + 499 + iii (paper)
Pluteo 5 sin. 6

The manuscript, written in two columns by several scribes in a simplified, small-module *littera textualis*, contains the most important work by the canonist Bernard of Parma: the gloss to the Decretals of Gregory IX, an immense corpus that took the author approximately three decades to complete and that rapidly came to be considered the fundamental work on the subject. This opus earned Bernard the title of *glossator* and *Decretalium apparatus compilator*.

The *pecia* indications in the margins of several folia demonstrate that it was written in a university setting. In order to satisfy the constant demand for textbooks, but also to ensure that the texts were correct and authentic, in the 13th century many European universities (particularly those in Paris and Bologna) devised a special system to increase the number of books. The *pecia* system essentially consisted of the simultaneous copying of separate sections (referred to as *pecie*, 'pieces') of a university text. A committee of *petiarii* appointed by the university and elected at the beginning of each academic year—as documented by statutes—was responsible for verifying the textual correctness of a work. Its *exemplar* (model), divided into 'pieces', was deposited at the workshops of the university's official *stationarii* (stationers) where, for a set fee, the *pecie* could be rented in order to be copied. Only the committee was authorized to approve the *exemplar*, which was checked periodically, determine its rental price (*taxatio*) and publish the list of selected texts approved by the university. The stationer, who was responsible for keeping the works entrusted to him in good condition, would display the list of *exemplaria*, indicating the number of *pecie* for each work and the rental fee. If requested by a customer, he would also handle distribution of the individual *pecie* to the scriptor to be copied and redelivered so that they could be rented again on a rotating basis. This meant that several copies could be made in the same amount of time usually required for just one. The scribes, who were generally laypeople and included women and students, often annotated the progressive number of each *pecia* they copied. These indications, which are sporadic on our manuscript, can be found in the margins in various forms to indicate the beginning or end of a *pecia*: "Hic finitur IIᵃ petia" (fol. 13v) or simply "Finitur XVI petia" (fol. 93r), "Sequitur IX petia secunde partis…" (fol. 322r), "petia X secunde partis" (fol. 331r), "XXXIIIᵃ petia" (fol. 415r).

The Library obtained the codex from the Florentine convent of Santa Croce in the second half of the 18th century, as documented by the notes on one of the paper flyleaves (iir).

The manuscript is open at fol. 13v, bearing on the left the indication "Hic finitur IIᵃ petia".

[E.A.]

Bandini 1774–8, IV, col. 52; Pomaro 1981, 424, 459–60; Murano 2005, 363.

32. Dante Alighieri, *The Divine Comedy*; Boethius, *De consolatione philosophiae* (vernacular translation)

Central Italy (Florence), 14th century
parchment; 325 × 230 mm (fols. 1–6), 372 × 267 mm (7–101); fols. iv (paper) + 101 + iv (paper)
Pluteo 90 sup. 125

This composite manuscript, written in two columns in an elegant bastard *cancelleresca* hand, consists of a main incomplete section containing Dante's three canticles, preceded by six folios with fragments from Cantos I–III, VIII–IX, XX–XXII, XXVIII and XXIX of the *Inferno*, serving as partial completion of the text, and followed by Alberto della Piagentina's vernacular translation of Boethius' *De consolatione philosophiae* (fols. 83r–101r), likewise incomplete. Alongside MS Triv. 1080, written in 1337 and so far the first dated example, this codex provides solid documentation of the activity of Francesco di ser Nardo da Barberino, who worked as a *scriptor* in Florence in the first half of the 14th century and subscribed the end of the third canticle (fol. 80v): "Franciscus ser Nardi me scripsit in Florentia. Anno Domini MCCCXLVII. Indictione Iª". The rubricated note is preceded by the scribe's initials, "F.N.", also rubricated. According to Petrocchi, the codex was the model for the group known as the 'Danti del Cento'. The story about a group of 100 manuscripts, all written by the same scribe who was forced to undertake this task so that he could afford a dowry for his daughters, originates from an anecdote recounted by the 16th-century scholar Vincenzo Borghini in his *Lettera intorno a' manoscritti antichi* (ed. Belloni 1995, 21): "During those times most scribes were people who had open shops and lived by copying books for a fee, and it is said that, with the 100 Dantes that he wrote, one of them married off I don't know how many daughters, and some of them, called those of the [group] of 100, can still be found". The scribe would later be identified as Francesco di ser Nardo. Today, however, he is credited with establishing an active scriptorium in Florence, in which other scribes he trained made elegant copies of Dante's work that were similar in layout (in two columns), decoration and script.

The decoration includes filigree initials and an initial adorned with plant motifs and a gold background on fol. 93r (the folios missing at the beginning of the canticles were probably illuminated as well), which Alvaro Spagnesi has tentatively attributed to the school of the Biadaiolo Master. The codex was once in the Gaddi family library (fol. ivr), part of which was purchased by the Biblioteca Laurenziana in 1755.

The manuscript is open at fol. 80v, bearing the subscription of Francesco di ser Nardo.

[E.A.]

Bandini 1774–8, V, cols. 399–400; Marchesini, 'Danti del Cento' 1890, 24; Marchesini, 'Ancora dei Danti del Cento' 1890, 20, 21; *Mostra di codici romanzi* 1957, 35–6; *Mostra di codici* 1965, 54; Petrocchi 1966, 66–7 and passim; Roddewig 1984, 63–4; Boschi Rotiroti 2000, 122, 125; Spagnesi 2000, 147, 150 note 8, figs. 9–11; Bertelli 2003, 410–2; Boschi Rotiroti 2004, 8, 18, 43 note 22, 45, 47, 72, 73, 77, 78 and note 22, 79, 81, 82 fig. 11, 84, 119, 156, 190 plate 22, 191 plate 23.

Cosi lamente mia tutta sospesa
mirava fissa inmobile e actenta
e sempre dimirar faciesi accesa

A quella luce cotal si diventa
che volgersi disei paltro aspetto
e impossibil che mai sicon senta

Pero chelben che delvolere obiecto
tucto saccoglie in lei e fuor digilla
e difectivo cio che li e perfetto

O mai sara pin corta mia favella
pur aquel chiricordo che dun fante
che bagni ancor la lingua alamamella

Non perche pin chun semplice sembiante
fosse nelvivo lume chio mirava
che tale sempre qual sera divante

Ma per la visista che savalorava
inme guardando una sola parvenca
immitandomio ame mirtavalliava

Ne la profonda e chiara subsistenca
del alto lume parvemi tre giri
di tre colori e duna contenenca

E l'un dalaltro chome iri dairi
parea reflexo el terzo parea foco
che quinci e quindi igualmente si spiri

O quanto e corto il dire e come fioco
almio concepto e questo aquel chi vidi
e tanto che non basta a dicer poco

O luce eterna che sola inte sidi
sola tintendi e date intellecta
e intendente te ami e arridi

Quella circulation chesi concepta
parena inte come lume reflexo
da liocchi mei alquanto circa spetta

Dentro dase delsuo color stesso
mi parve pinta della nostra effige
per che'l mio viso in tutto avea inmesso

Qual e'l geometra che tutto saffige
per misurar lo cerchio e no ritruova
pensando quel principio ond elli indige

Tal era io aquella vista nova
veder volea come siconvenne
l'ymagine al cerchio e come vi si ndua

Ma non eran dicio le proprie penne
se non che la mia mente fu percossa
da un folgore inche sua voglia venne

A lalta fantasia qui manco possa
ma gia volgea il mio disio il velle
si come rota che igualmente e mossa

L'amor che move el sole e l'altre stelle :~

Explicit liber Commedie Dantis
Allaghery de florentia · pen certina
sub anno dominice Incarnationis
millesimo Trecentesimo · de mense
martij sole in ariete · Luna · viiij in
libra :~

Qui decessit in Ciuitate Rauene
in Anno dnice Incarnati dccc xxi
die sancte crucis de mense septe
aia cui requiescat in pace · Amen :~

f.n.

Franciscus snardi me scripsit in
florentia · Anno dni oxxx xlviij · Ind. j.

33. Latin miscellany (autograph manuscript by Giovanni Boccaccio)

Florence?–Naples–Romagna, 14th century
parchment; 288 × 208 mm; fols. v (paper) + 73 + iv (paper)
Pluteo 33.31

The manuscript contains an anthology of classic and medieval Latin writers, bearing witness to the eclectic and singular cultural interests of Boccaccio, who prepared and copied it in several stages and different circumstances. The volume includes Fulgentius' *Expositio sermonum antiquorum* (fols. 1r–3r), Persius' *Satirae* (4r–16v), several texts from the *Appendix Vergiliana* (*Culex* and *Dirae*, 17r–27v; *Priapea*, 39r–45v), Ovid's *Ibis* (46v–9r) and *Amores* (49v–59r), the *Megacosmus et Microcosmus* by Bernard Silvestris (59v–67r), the medieval plays *Geta* by Vital of Blois (67v–9r), *Alda* by William of Blois (69v–71v) and *Lydia* by Arnulf of Orléans (71v–3v), a collection of aphorisms and various poems from the *Anthologia Latina*. This collection is exceptional due also to the fact that several minor texts in it have been handed down to us solely through this manuscript (or very few others). Examples include the tetrastich in honour of St Minias (fol. 3v), the *Lamentatio Bertoldi*, a scholastic cento of classical and middle-Latin quotations (ibid.), and the sole extant fragment of Lovato Lovati's poem on Tristan and Isolde (fol. 46r).

Boccaccio's hand has been identified not only in the text, but also in the numerous marginal and interlinear notes, which provide evidence of his graphic and decorative talent. In the margins of fol. 4r the glosses are arranged so as to form a 'jug', a flower, a trilobate leaf (left margin) and other geometric shapes. The *maniculae* in a variety of gestures and positions are also in Boccaccio's own hand (fol. 12v shows a three-button sleeve).

The fate of this codex is entwined with that of the so-called Zibaldone Laurenziano (Plut. 29.8). The two manuscripts, which were once joined, were both made in part with palimpsest leaves from a 13th-century gradual in Beneventan script. The codex belonged to Antonio Petrei (1498–1570), scholar and canon of the Florentine basilica of San Lorenzo, as indicated in the ownership inscription on fol. ivr (but actually vr), and in the erased note on fol. 1r. The Biblioteca Laurenziana obtained it, along with 19 other manuscripts owned by Petrei, in the third quarter of the 16th century.

The manuscript is open at fol. 4r, with the incipit of Persius' *Satirae*.

[E.A.]

Bandini 1791–3, II, cols. 124–8; Da Rif 1973, 59–124; *Mostra di manoscritti* 1975, I, 122–4, no. 101; *Gli Zibaldoni di Boccaccio* 1998; *Boccaccio visualizzato* 1999, II, 53–4, no. 1.

4

VITA PERSII FLACCI INCIPIT FELICITER

EXPLICIT VITA PERSII PROLOGVS INCIP

PERSII FLACCI PREFATIO SATIRVM INCIP

34. Quintilian, *Institutio oratoria*

Central Italy (Florence), 15th century (13 March 1477: see the colophon with the date
written in the Florentine style at fol. 248r)
parchment; 335 × 234 mm; fols. i + 248 + i
Pluteo 46.12

In terms of its materials, script and ornamentation, this codex is a typical example of the
high-quality Florentine manuscript production of the second half of the 15th century. Writ-
ten in humanistic script, it was the work of two professional scribes identified by Albinia de
la Mare (1985) as the scribe of MS Urb. Lat. 441 (fols. 1r–100v, 144r–248r) and *Gundisalvus
de Heredia* (fols. 101r–43v). The artist who created the rich and extremely elegant illustra-
tions distinguishing the various sections of the text has also been identified. The painter was
Francesco Rosselli (1448–after 1508), who in the 1470s and early 1480s worked for a number
of illustrious patrons, in whose honour he devised "extremely refined and sumptuous decor-
ative concepts" (Di Domenico 2005). For the Medici, in particular, in addition to this work
Rosselli also illuminated two Aristotelian codices (Plut. 71.7 and 84.1), a copy of the *Iliad*
(Plut. 32.4), a codex of Lucan (Plut. 91 sup. 32) and one of Herodotus (Plut. 67.1). In all of
these works he displays perfect mastery of the humanistic decorative repertory, composed
of candelabra, putti, cameos, masks, cornucopias, clipei (medallions), flaming basins, her-
aldic devices and idealized portraits. In the initial *P* on fol. 1r the bust of Quintilian, garbed
"in the Greek style" to evoke the figure of the Eastern sage, is particularly striking (*Vedere
i classici* 1996).

The manuscript was produced for Lorenzo (1463–1503) and Giovanni (1467–98), sons
of Pier Francesco de' Medici (the Medici coat of arms can be seen in the middle of the low-
er border of fol. 1r), as also noted in the ownership inscription written on fol. 248r by their
teacher Giorgio Antonio Vespucci (1434–1514), who added many Greek words in the blank
spaces left by the scribes (Daneloni 2001). Vespucci's interest in this text is not surprising,
given the fact that the merits of the *Institutio oratoria*—educational and otherwise—were
widely acknowledged in the 15th century. For example, both Lorenzo Valla (1407–57) and
Politian (1454–94) noted that its methodical structure and clear, exhaustive style made it
ideal for teaching rhetoric.

The manuscript is open at fol. 1r, with the incipit of the treatise and the portrait of Quin-
tilian.

[S.M.]

Bandini 1774–8, II, cols. 385–6; De la Mare 1985, 503, 551; *Vedere i classici* 1996, 455; Daneloni 2001,
70–1; Di Domenico 2005, 112, 128.

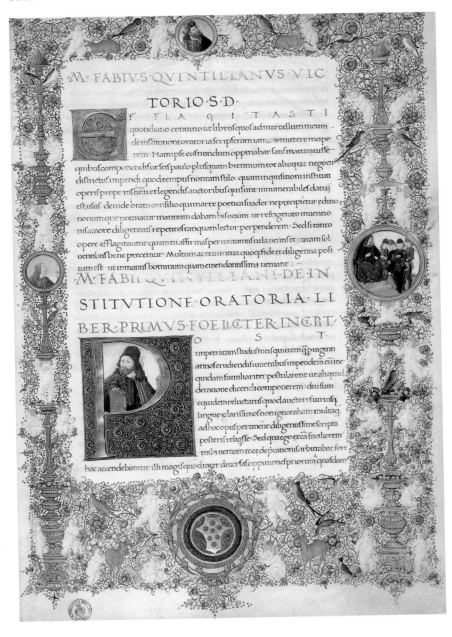

M. FABIVS QVINTILIANVS VIC
TORIO S D

E FLAGITASTI
quotidiano conuitio ut libros quos ad marcellum meum
de institutione oratoria scripseram iam emitterem inciperem. Nam ipse eos nondum oppinabar satis maturuisse quibus componendis ut scis paulo plusquam biennium tot alioqui negotiis districtus impendi quod tempus non tam stilo. quam inquisitioni instituti operis prope infiniti et legendis auctoribus qui sunt innumerabiles datum est. usus deinde oratii consilio qui in arte poetica suadet ne precipitetur editio nonum que prematur in annum dabam his ocium ut refrigerato inuentionis amore diligentius repetitos tanquam lector perpenderem. Sed si tanto opere efflagitantur quam tu affirmas permittamus uela uentis et oram soluentibus bene precemur. Multum autem in tua quoque fide et diligentia positum est. ut in manus hominum quam emendatissima ueniant :

M. FABII QVINTILIANI DE IN
STITVTIONE ORATORIA LI
BER PRIMVS FOELICTER INCPT

POST imperatam studiis meis quietem cum per uiginti annos erudiendis iuuenibus impenderem cum me quidam familiariter postularent ut aliquid de ratione dicendi componerem. diu sum equidem reluctatus quod auctores utriusque lingue clarissimos non ignorabam multaq; ad hoc opus pertinent diligentissime scripta posteris reliquisse. Sed qua ego excusatione faciliorem mihi ueniam meae deprecationis arbitrabar fore hac accendebantur illa magis quod inter diuersas oppiniones priorum quasdam

35. Bible

Central Italy (Tuscany), beginning of the 12th century
parchment; 570 × 398 mm; fols. i + 285 + i
Edili 125

The two volumes of the Bible of Santa Maria del Fiore (Edili 125–6) are extraordinary examples of monumental or 'giant' Bibles, as they have been dubbed in academic circles. It is unknown who commissioned the manuscript, but it has been documented among the codices in the sacristy of Florence Cathedral since at least 1418; it remained there until 1778, when it was transferred to the Biblioteca Laurenziana.

The complex ornamentation of the Bible—which follows a precise functional hierarchy and contains decorated pages, illustrated pages, free figures in the columns of texts, and historiated and figured initials—parallels iconographic solutions (a youthful version of God the Father) found in giant Bibles from Rome (e.g. the Pantheon Bible, Vat. Lat. 12958; the Santa Cecilia Bible, Barb. Lat. 587; the Todi Bible, Vat. Lat. 10405; the Bible now in Perugia, Biblioteca Comunale Augusta, MS L 59), the fresco cycles at San Giovanni a Porta Latina in Rome and San Pietro in Valle in Ferentillo (Terni), and French, English, Spanish and even Oriental pictorial models.

According to Timothy Chasson (1979), however, what distinguishes the illustrative cycle of this Bible is its repetition of the motifs of the 'fall' of man and 'anointment', i.e. sin on the one hand and legitimate sacerdotal consecration on the other. Therefore, its iconographic programme parallels the reforms promoted by Pope Gregory VII (1073–85) and his successors. Its complexity has led to the assumption that there was "an author—the patron, a theological counsellor or supervisor—who oriented the choices of those who executed it" and who may have been connected with the milieu of the Florentine cathedral in the early 12th century (*Le Bibbie atlantiche* 2000, 278).

The manuscript is open at fol. 212r, with miniatures depicting the vision and stoning of Jeremiah, and the initials of the Prologue and the Book of Jeremiah.

[S.M.]

Bandini 1791–3, I, cols. 226–31; Chasson 1979, 145–300; *Le Bibbie atlantiche* 2000, 271–8 (with bibliography).

reximus Librū aūt baruch natarii
tiuſ quiapudhebreos nee legitur
nechabetur · ptermiſim ꝑhis oĩbꝯ
maledicta abemulif ꝑſtolantes
quibꝯ me neceſſe · ē ꝑ ſingula · opeula
reſponderc · ethoepatior · qꝛ uoſ eo
gitiſ Ceterũ adconpendiū malī recꝛ
tiuſ fuerat modū furori eoꝛ ſilen
tio meo ponere · quā cottidie noui
aliqꝺ ſcriptitante inuidoꝛ inſania
prouo care

EXPLICIT PROLOGVS

INCᴘ PROLOGꝰ S HER
INIHEREMIA PROPHETA

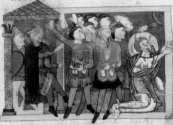

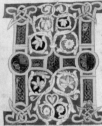

IEREMI
AS · PPHA
cui hic pro
loguſ ſcribiꝵ
ſermone qdē
apudhebreoſ
yſaïas etoſee
et quibuſdā
aliiſ ꝑphiſ
uidenꝵ eſſe
ruſticior ſed

ſenſibꝯ par eſt · Quippe qui eo dē ſpū
ꝑphauerit · Porro ſimplicitaſ eloqi
delocoetiꝺ nacꝵ ē accidit Fuit eni
anathothiteꝛ quiē uſqꝛ hodie uncul
tribꝯ abihero ſolumiſ diſtanſ milibꝯ
Sacerdoſ exſacꝺotibꝯ et inmatriſ utꝺ
ſciſicat · Uirginitate ſua eugꝷicum
uiru ẋpi eccſe dedicanſ Hic uatici
nari exorſuſ ē puer et captiuitate
urꝪ atqꝛ iudee inſolū ſpū ſedoculiſ
carniſ intuituſ ē · Iam decē tribꝯ iſrł
aſſyrii inmedoſ tranſtulerant · Iam
iraſ eurū colonie gentiū poſſidebaꝵ
Unde iniuda tantū etbeniamin ꝑpha
uit · E ciuitatiſ ſue ruinaſ qꝺruplici
plāe alfabeto · qꝯ noſ iſure metri
uerſibuſqꝛ reddidimuſ · Preter ea or
dine uiſioni · quiapudgrecoſ etlatini
omino ēfuſuſ ē adpriſtinā fidē cor

INCᴘ LIB IHEREMIE ᴘᴘE

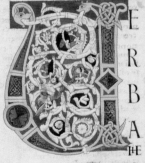

E
R
B
A
HE

REMIE PROPHAE FILI
hel chie · DESACERDOTIBVS

36. Bible

France, 13th century
165 × 110 mm
Pluteo 3, capsula I

The codex is a typical example of a 'hand' Bible, i.e. a compact manuscript with the complete Latin text of the Old and New Testaments, intended for individual reading and study, and often associated with the preaching work of the mendicant orders. This one has become known as the 'Bible of Marco Polo' based on the testimony of the Jesuit Procurator General Philippe Couplet (1624–92), who gave it to Cosimo III, the grand duke of Tuscany. The latter was an inquisitive traveller, as demonstrated by some of the other works he owned, such as *Il Viaggio di Cosimo* (Med. Palat. 123) and the Carte di Castello. According to Couplet, the family of an eminent figure from Cham Xo, in Nanking Province, had jealously guarded the codex for 400 years, convinced that it was a Bible that had belonged to Marco Polo or some other European traveller.

Despite scholars' objections to this attribution—due to the fact that the biblical text is not cited in Marco Polo's work, that he was quite young when he went to China, that he knew very little Latin and that Bibles were rarely used by merchants and laymen, together with uncertainty over the site where it was discovered—there is no decisive evidence for rejecting this fascinating hypothesis. Unfortunately, its extremely poor state of conservation makes additional study impossible.

Nevertheless, one thing is certain: the codex is a Library treasure providing important documentation on the use of books, and it has never been displayed before. It seems likely that this Bible, which was made in France, was one of the accoutrements of a traveller, probably a Franciscan from the first mission that the order sent to China. When the missions were closed, it was brought to Italy wrapped in a precious cloth, an ancient piece of yellow silk that is unquestionably Oriental and was traditionally used to protect particularly valuable objects.

[F.A.]

Biscioni 1752–[7], 121; Bandini, ed. 1990, 92 and note 40; Szcześniak 1955; Szcześniak 1957.

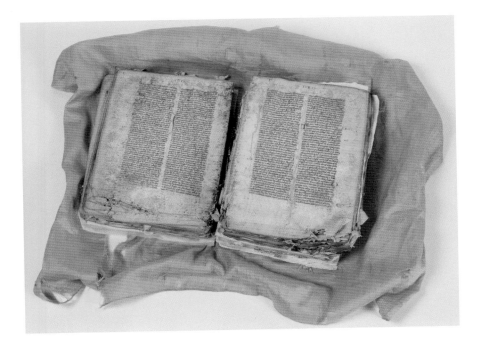

37. Miscellany of Latin and vernacular poems

Tuscany, 17th century
paper; 197 × 133 mm; fols. iii + 144 + i
Redi 28

This miscellany, with poems by various 16th- and 17th-century authors such as Alessandro Adimari, Antonio Aldrovandi, Lorenzo Azzolini, Bonavita Capezzali, Pier Francesco Minozzi and Ciro di Pers, belonged to Francesco Redi (1626–97), who also wrote one of its sections. Considered one of the founders of modern medicine and biology, Redi is unquestionably one of the most polymathic and interesting scientists of the Italian and European tradition, a rare figure who merged courtly life with a passion for scientific research, arts and letters, and ancient manuscripts. Chief physician to two grand dukes of Tuscany, Ferdinando II and Cosimo III, and the author of works destined to become milestones in the history of modern science, the Arezzo-born scholar was also a member of the Accademia dell'Arcadia, one of the most active representatives of the Accademia del Cimento, and Archconsul of the Accademia della Crusca, where he was appointed to correct and expand the entries in the Dictionary of the Italian Language. A sophisticated man of letters, he began to cultivate poetry at an early age, not "as a profession, but as a pastime and a way to escape idleness", as he wrote to Federigo Nomi in a letter dated 10 June 1690. One of his most notable literary works is the famous dithyramb *Bacco in Toscana*, a brilliant poem in praise of wine that was published in 1685 and is considered a masterpiece of escapist literature. The manuscripts collected by Redi and part of his enormous correspondence were bequeathed to the Biblioteca Medicea Laurenziana in 1820 by Redi's last heir, Francesco Saverio Redi. Fol. 144v (above, a detail) shows the family crest drawn in pen, possibly by Redi himself.

The manuscript is open at fol. 70v, which contains Redi's ode *De Herculis et Antei pugna* written in the author's own hand.

[E.A.]

Del Furia [1858], fols. 453r–5r; Innocenti 1984, 137 note 55.

13 β

De Herculis et Antei pugna
Ode Fran: Redij Aretini

Jovis Alcides Jovis alma proles
Qui neci sorvum tribuit leonem
Qui renascentem funeravit Hydram
 Igne voraci

Iste telluris libico Giganti
Sorte luctatur dubia et superba
Non ob gratum tripodam lebetem
 Atq galentam

Non ob Ancillam munieas
Non ob Auratam galeam pe plumae
Sed retinebant miserum quis ires
 Pronus ad iras

Victus Antæus domitus domanti
Herculis destra cecidit superbus
Te nihil magne potuere matris
 Impia gesta

Jure et Alcides retulit triumphum
Nam levis ludus nitidiq palestræ
Et ferox pubis Danai ferocis
 Non libycor

38. Elyas Yusof Nezami Ganjavi, *Khamseh* ('The Quintuplet')

Persia, first half of the 16th century
paper; 240 × 190 mm; fols. 314
Orientale 11

The manuscript, on polished Oriental paper, is an elegant copy of the *Khamseh*, a pentalo-
gy of poems (*The Treasury of Mysteries, Khosrow and Shirin, The Story of Leyla and Majnun,
The Seven Beauties* and the *Book of Alexander the Great*) by Elyas Yusof Nezami Ganjavi
(1140–1200), the greatest romantic epic poet in Persian literature. It was written in fine *nas-
ta'liq* script by a single scribe who subscribed the text but did not sign his name (fol. 314r).

The Ottoman captain of the fleet Kara Mustafa Paşa (1635–83) donated this work and MS
Orientale 5 (the royal chronicle by Firdawsī) to Grand Duke Ferdinando II (1621–70). Thus,
it became part of the Palatine library collections, some of which were transferred to the Bi-
blioteca Medicea in 1783.

The epigraph is set in a rich symmetrical *sarlauh* (illuminated heading) decorated with
central medallions (fols. 1v–2r), which is also found inside the book (fols. 2v, 28v, 101v, 149v,
201v, 275v). There are also twelve well-preserved half-page miniatures by different illumina-
tors, some of which exquisitely made (fols. 17v, 41v, 306r). They have been attributed to a
Western Iranian workshop and were executed in the Shīrāz style.

The manuscript is open at fol. 306r, illustrating Alexander's banquet with the Chinese
maiden.

[I.G.R.]

Assemani 1742, 148–9; *Biblioteca Medicea* 1986, 271–3, plates CCVI–CCVII; Piemontese 1989, 65–6,
no. 80; *Islam specchio d'Oriente* 2002, 106, no. 81.

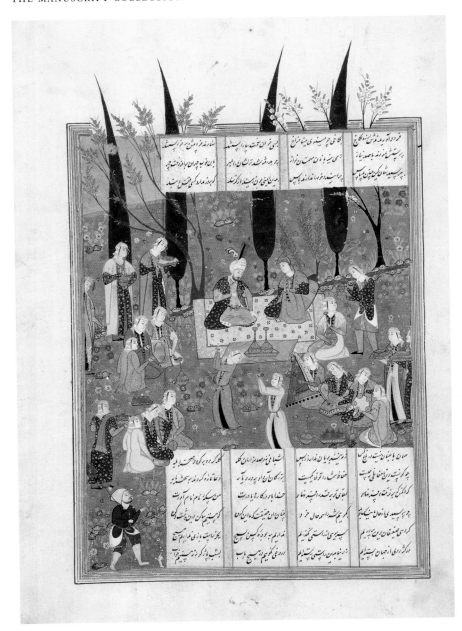

39. *Crossing the frontier*

China, 16th–17th century
silk and paper; 530 × 12700 mm
Acquisti e Doni 777

The various characteristics typical of Chinese painted horizontal scrolls can be distinguished in this work. It was painted on silk and mounted on an ivory base, also made of silk, glued to a stiffer paper backing that is nevertheless easy to fold. A wooden rod with jade elements at the ends is fastened to the short end of the scroll and makes it easy to open (from right to left). A much thinner rod is mounted at the other end, and attached to it is a ribbon that ends in a clasp, also made of jade.

According to James Cahill, the painted scene depicts the journey, across the frontier, of the imperial concubine Wang Zhaojun (Mingfei), whom the emperor Yuandi (48–32 BC) betrothed to a Xiongnu chieftain. This extremely well-known story is often represented in albums and scrolls of different sizes and qualities (for example, the scroll painted by Gong Suran in the early 12th century, now part of the Abe Collection at the Osaka Municipal Museum of Art). Cahill (2006) has theorized that these scrolls were made specifically for an audience of women.

The illustrated scene bears the signature and two of the chops (seals) of the Ming master Dai Wen Jin (1388–1462), but stylistic elements disprove his paternity of this work. Attributions to Chen Hongshou (1599–1652) and Fu Shan (1605–90), cited in two of the many colophons, are also false, as reported by Giovanni Peternolli.

The Library acquired this scroll in 1981.

[S.M.]

Bandini, ed. 1990, 92 note 39; *Biblioteca Medicea* 1986, 278.

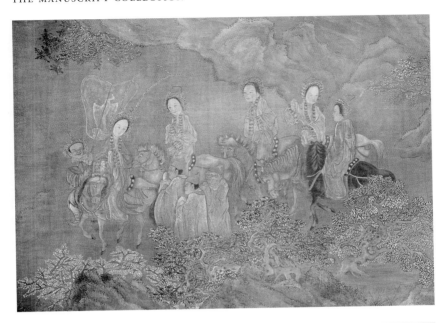

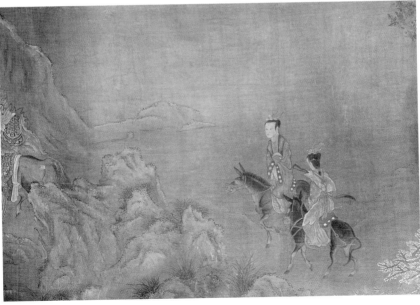

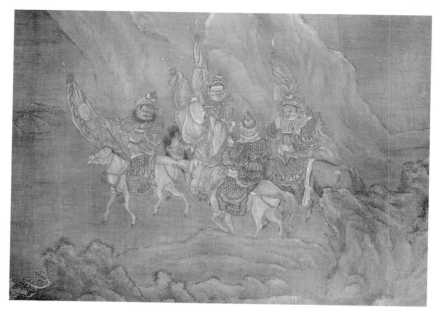

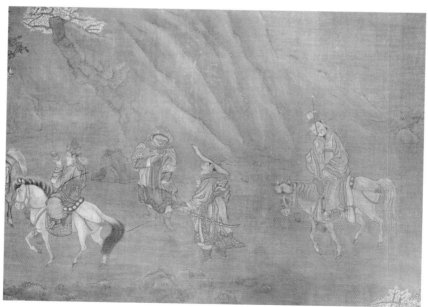

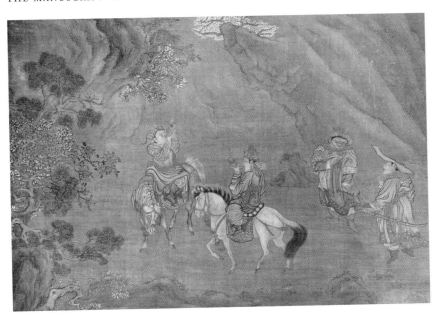

40. *Phallic contest*

Japan, 19th century
paper; 365 × 4165 mm
Acquisti e Doni 794

This specimen presents the characteristic elements of Japanese horizontal illustrated scrolls, one of the country's oldest pictorial forms. Specifically, it is a scroll from the late Edo period (1603–1867) and is composed of several juxtaposed sheets of Japanese paper that are 'read' from right to left.

The scroll features watercolour drawings that, as noted by Giovanni Peternolli, portray the subject of the phallic contest (*yōbutsu-kurabe*), a motif typical of Japanese humorous erotica first developed in the 11th century. In terms of its execution and iconographic choices, this piece closely parallels a work by Suzuki Shōnen (1849–1918) depicting the same theme and reproduced in *Ukiyo-e. A Journal of Floating-World Art* (no. 77, 1977, 127–30).

The Library acquired this scroll in 1982.

[S.M.]

Bandini, ed. 1990, 92 note 39; *I manoscritti datati* 2004, 5 note 10.

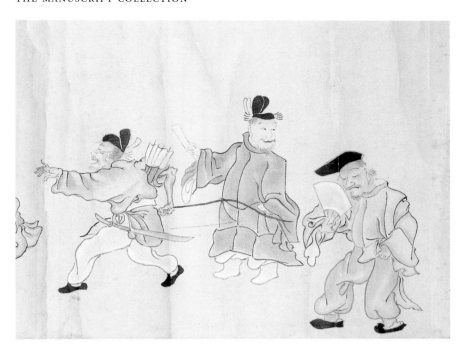

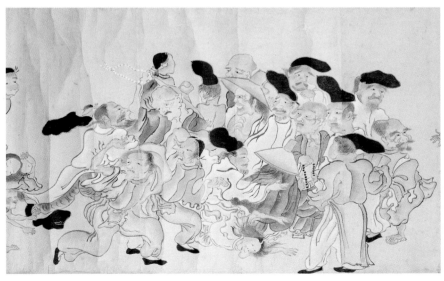

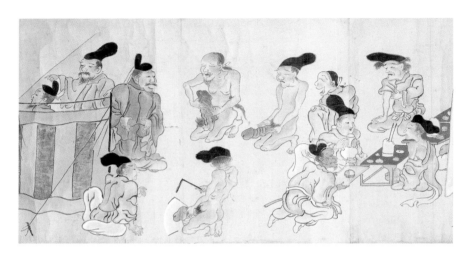

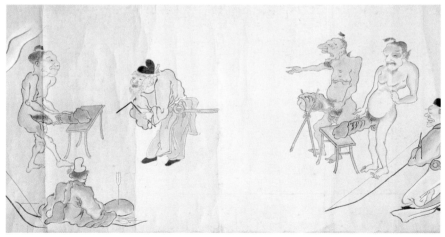

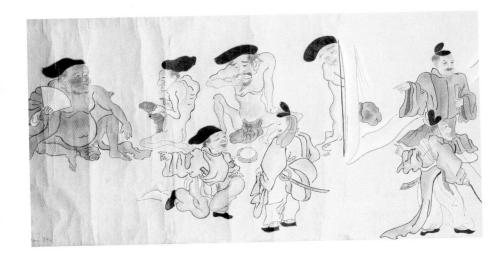

Bibliographical references

Gli archivi della memoria 1996 = *Gli archivi della memoria. Bibliotecari, filologi e papirologi nei carteggi della Biblioteca Medicea Laurenziana*, exhibition catalogue (Florence, Biblioteca Medicea Laurenziana, 1996), edited by R. Pintaudi, Florence 1996.

Assemani 1742 = *Bibliothecae Mediceae Laurentianae et Palatinae codicum mss. Orientalium catalogus*, Stephanus Evodius Assemanus … recensuit, digessit, notis illustravit, Antonio Francisco Gorio curante, Florentiae, Ex Typographio Albiziniano, 1742.

Avesani 1962 = R. Avesani, 'Il *De viris illustribus antiquissimis qui ex Verona claruere*', *Italia medioevale e umanistica*, 5 (1962), 48–84.

Bandini 1764–70 = *Catalogus codicum manuscriptorum Bibliothecae Mediceae Laurentianae varia continens opera Graecorum patrum*, … Angelus Maria Bandini … recensuit, illustravit, edidit, 3 vols., Florentiae, Typis Caesareis, 1764–70.

Bandini 1774–8 = *Catalogus codicum Latinorum Bibliothecae Mediceae Laurentianae*, … Angelus Maria Bandini … recensuit, illustravit, edidit, 5 vols., Florentiae, Typis Caesareis, 1774–8.

Bandini 1791–3 = *Bibliotheca Leopoldina Laurentiana, seu Catalogus manuscriptorum qui iussu Petri Leopoldi … in Laurentianam translati sunt*, … Angelus Maria Bandini … recensuit, illustravit, edidit, 3 vols., Florentiae, Typis Regiis, 1791–3.

Bandini, ed. 1990 = Angelo Maria Bandini, *Dei princìpi e progressi della Real Biblioteca Mediceo Laurenziana (Ms. laur. Acquisti e Doni 142)*, edited by R. Pintaudi, M. Tesi, A.R. Fantoni, Florence 1990.

Bertelli 2003 = S. Bertelli, 'I codici di Francesco di ser Nardo da Barberino', *Rivista di studi danteschi*, 3 (2003) 2, 408–21.

Le Bibbie atlantiche 2000 = *Le Bibbie atlantiche. Il libro delle Scritture tra monumentalità e rappresentazione*, exhibition catalogue (Abbey of Montecassino, 2000; Florence, Biblioteca Medicea Laurenziana, 2000–1), edited by M. Maniaci and G. Orofino, [Milan] 2000.

La biblioteca di Michelozzo 2000 = *La biblioteca di Michelozzo a San Marco tra recupero e scoperta*, exhibition catalogue (Florence, Museo di San Marco, 2000), edited by M. Scudieri and G. Rasario, Florence 2000.

Biblioteca Medicea 1986 = *Biblioteca Medicea Laurenziana*, Florence 1986.

Biscioni 1752–[7] = *Bibliothecae Mediceo-Laurentianae catalogus*, ab Antonio Maria Biscionio … digestus atque editus, 2 tomes in 1 vol., Florentiae, Ex Imperiali Typographio, 1752–[7]: I, *Codices Orientales complectens*; II, *Codices Graecos complectens*.

Boccaccio visualizzato 1999 = *Boccaccio visualizzato. Narrare per parole e immagini fra Medioevo e Rinascimento*, edited by V. Branca, 3 vols., Turin 1999.

Borghini, ed. Belloni 1995 = Vincenzio Borghini [1515–80], *Lettera intorno a' manoscritti antichi*, edited by G. Belloni, Rome 1995.

Boschi Rotiroti 2000 = M. Boschi Rotiroti, 'Accertamenti paleografici su un gruppo di manoscritti danteschi', *Medioevo e Rinascimento*, new ser., 11 [14] (2000), 119–28.

Boschi Rotiroti 2004 = M. Boschi Rotiroti, *Codicologia trecentesca della "Commedia". Entro e oltre l'antica vulgata*, Rome 2004.

Cahill 2006 = J. Cahill, 'Paintings Done for Women in Ming-Qing China?', *Nan Nü: Men, Women, and Gender in China*, 8 (2006), 1–54.

Charlet 2003 = *Deux pièces de la controverse humaniste sur Pline: N. Perotti, lettre à Guarnieri, C. Vitelli, Lettre à Partenio di Salò*, critical edition and commentary, [edited by] J.-L. Charlet, Sassoferrato 2003.

Chasson 1979 = R.T. Chasson, *The Earliest Illustrated Tuscan Bible (Edili 125/126)*, 2 vols., Ph.D. Diss., Berkeley, Calif., University of California, 1979.

I codici Ashburnhamiani 1887–1917 = *I codici Ashburnhamiani della R. Biblioteca Mediceo Laurenziana di Firenze*, [edited by C. Paoli, E. Rostagno], I, issues 1–5, Rome 1887–1917.

Daneloni 2001 = A. Daneloni, *Poliziano e il testo dell'"Institutio oratoria"*, Messina 2001.

Da Rif 1973 = B.M. Da Rif, 'La Miscellanea Laurenziana XXXIII.31', *Studi sul Boccaccio*, 7 (1973), 59–124.

De la Mare 1985 = A.C. de la Mare, 'New Research on Humanistic Scribes in Florence', in *Miniatura fiorentina del Rinascimento 1440-1525. Un primo censimento*, edited by A. Garzelli, 2 vols., Florence 1985, I, 393–600.

Del Furia [1858] = F. Del Furia, *Supplementum alterum ad catalogum codicum Graecorum, Latinorum, Italicorum etc. Bibliothecae Mediceae Laurentianae*, [Florence, before 1858], 4 vols., Florence, Biblioteca Medicea Laurenziana, MS.

Di Benedetto 1972 = F. Di Benedetto, 'Il Plinio Laurenziano proviene veramente da Lubecca', in *Studi classici in onore di Quintino Cataudella*, 3 vols., Catania 1972, III, 437–45.

Di Domenico 2005 = A. Di Domenico, 'I miniatori', in *Il Libro d'ore di Lorenzo de' Medici*, Commentary edited by F. Arduini, Modena [2005], 107–39.

Ferrari 2001 = F. Ferrari, 'Sindrome da attacco di panico e terapia comunitaria: sui frgg. 31 e 2 V. di Saffo', in *I lirici greci. Forme della comunicazione e storia del testo*, Proceedings of the Colloquium (Messina, 5–6 November 1999), edited by M. Cannatà and G.B. D'Alessio, Messina 2001, 47–61.

Firenze e la scoperta dell'America 1992 = *Firenze e la scoperta dell'America. Umanesimo e geografia nel '400 fiorentino*, exhibition catalogue (Florence, Biblioteca Medicea Laurenziana, 1992), edited by S. Gentile, Florence 1992.

Hunt 2007 = E.M. Hunt, *Illuminating the Borders of Northern French and Flemish Manuscripts, 1270-1310*, New York–London 2007.

Index 1768 = *Index manuscriptorum Bibliothecae Ff. ordinis Praedicatorum Florentiae ad Sanctum Marcum*, Anno Domini MDCCLXVIII, Florence, Biblioteca Medicea Laurenziana, MS San Marco 945.

Innocenti 1984 = P. Innocenti, *Il bosco e gli alberi. Storie di libri, storie di biblioteche, storie di idee*, 2 vols., Florence 1984.

Islam specchio d'Oriente 2002 = *Islam specchio d'Oriente. Rarità e preziosi nelle collezioni statali fiorentine*, exhibition catalogue (Florence, Palazzo Pitti, Sala Bianca, 2002), edited by G. Damiani and M. Scalini, Livorno 2002.

Lobel–Page 1955 = *Poetarum Lesbiorum fragmenta*, ediderunt E. Lobel et D. Page, Oxford 1955.

I luoghi della memoria 1994 = *I luoghi della memoria scritta. Manoscritti, incunaboli, libri a stampa di Biblioteche Statali Italiane*, directed by G. Cavallo, Rome 1994.

I manoscritti datati 2004 = *I manoscritti datati del fondo Acquisti e Doni e dei fondi minori della Biblioteca Medicea Laurenziana di Firenze*, edited by L. Fratini and S. Zamponi, Florence 2004.

Marchesini, 'Danti del Cento' 1890 = U. Marchesini, 'I Danti del Cento', *Bullettino della Società Dantesca Italiana*, 2–3 (1890), 21–42.

Marchesini, 'Ancora dei Danti del Cento' 1890 = U. Marchesini, 'Ancora dei Danti del Cento', *Bullettino della Società Dantesca Italiana*, 4 (1890), 19–26.

Marrassini 1987 = P. Marrassini, 'I manoscritti etiopici della Biblioteca Medicea Laurenziana di Firenze' [II], *Rassegna di studi etiopici*, 31 (1987), 69–110.

Marsilio Ficino 1999 = *Marsilio Ficino e il ritorno di Ermete Trismegisto*, exhibition catalogue (Florence, Biblioteca Medicea Laurenziana, 1999–2000), edited by S. Gentile and C. Gilly, Florence 1999.

Mostra di codici 1965 = *Mostra di codici ed edizioni dantesche*, exhibition catalogue (Florence, Biblioteca Nazionale Centrale, 1965), Florence 1965.

Mostra di codici romanzi 1957 = *Mostra di codici romanzi delle biblioteche fiorentine*, exhibition catalogue (Florence, Biblioteca Medicea Laurenziana, 1956), [VIII Congresso internazionale di studi romanzi (3–8 April 1956)], Florence 1957.

Mostra di manoscritti 1975 = *Mostra di manoscritti, documenti e edizioni*, exhibition catalogue (Florence, Biblioteca Medicea Laurenziana, 1975), [VI Centenario della morte di Giovanni Boccaccio], 2 vols., Certaldo 1975: I, *Manoscritti e documenti*; II, *Edizioni*.

Murano 2005 = G. Murano, *Opere diffuse per "exemplar" e pecia*, Turnhout 2005.

Norsa 1937 = M. Norsa, 'Dai papiri della Società Italiana. Versi di Saffo in un ostrakon del sec. II a.C.', *Annali della Scuola Normale Superiore di Pisa*, 2nd ser., 6 (1937), 8–15.

I papiri dell'archivio di Zenon 1993 = *I papiri dell'archivio di Zenon a Firenze. Mostra documentaria*, exhibition catalogue (Florence, Biblioteca Medicea Laurenziana, 1993), edited by G. Messeri Savorelli and R. Pintaudi, Florence 1993.

Papiri greci e latini 1912– = *Papiri greci e latini*, Florence 1912–.

Petrocchi 1966 = G. Petrocchi, *I. Introduzione* [1966], in Dante Alighieri, *La Commedia secondo l'antica vulgata*, edited by G. Petrocchi, 4 vols., Milan 1966–7.

Piccolomini 1874–5 = E. Piccolomini, 'Due documenti relativi ad acquisti di codici greci, fatti da Giovanni Lascaris per conto di Lorenzo de' Medici', *Rivista di filologia e d'istruzione classica*, 2 (1874), 401–23; *Aggiunte e modifiche*, ibid., 3 (1875), 1–4 [offprint: 3–24].

Piemontese 1989 = A.M. Piemontese, *Catalogo dei manoscritti persiani conservati nelle biblioteche d'Italia*, Rome 1989.

Pomaro 1981 = G. Pomaro, 'Manoscritti peciati di diritto canonico nelle biblioteche fiorentine', *Studi medievali*, 3rd ser., 22 (1981) 1, 421–66.

Relazione 1884 = *Relazione alla Camera dei Deputati e Disegno di Legge per l'acquisto di codici appartenenti alla Biblioteca Ashburnham descritti nell'annesso Catalogo*, Rome 1884.

Roddewig 1984 = M. Roddewig, *Dante Alighieri, Die Göttliche Komödie. Vergleichende Bestandsaufnahme der Commedia-Handschriften*, Stuttgart 1984.

Scrivere libri e documenti 1998 = *Scrivere libri e documenti nel mondo antico. Mostra di papiri della Biblioteca Medicea Laurenziana*, exhibition catalogue (Florence, Biblioteca Medicea Laurenziana, 1998), edited by G. Cavallo et al., Florence 1998.

Spagnesi 2000 = A. Spagnesi, 'All'inizio della tradizione illustrata della *Commedia* a Firenze: il codice Palatino 313 della Biblioteca Nazionale di Firenze', *Rivista di storia della miniatura*, 5 (2000), 139–50.

Szcześniak 1955 = B.B. Szcześniak, 'The Laurentian Bible of Marco Polo', *Journal of the American Oriental Society*, 75 (1955) 3, 173–9.

Szcześniak 1957 = B.B. Szcześniak, 'A Note on the Laurentian Manuscript Bible of the Franciscan Missionaries in China (14th Century)', *Monumenta Serica*, 16 (1957), 360–2, plate III.

Ullman–Stadter 1972 = B.L. Ullman, Ph.A. Stadter, *The Public Library of Renaissance Florence. Niccolò Niccoli, Cosimo de' Medici, and the Library of San Marco*, Padua 1972.

Vedere i classici 1996 = *Vedere i classici: l'illustrazione libraria dei testi antichi dall'età romana al tardo Medioevo*, exhibition catalogue (Vatican City, Vatican Museums, Salone Sistino, 1996–7), edited by M. Buonocore, Rome 1996.

Vogel 1854 = E.G. Vogel, 'Litterarische Ausbeute von Janus Lascaris' Reisen im Peloponnes um's Jahr 1490', *Serapeum*, 15 (1854) 10, 154–60.

Gli Zibaldoni di Boccaccio 1998 = *Gli Zibaldoni di Boccaccio. Memoria, scrittura e riscrittura*, Proceedings of the International Symposium (Florence–Certaldo, 26–8 April 1996), edited by M. Picone and C. Cazalé Bérard, Florence 1998.

TABLE OF CONTENTS

Printed by Alpilito, Firenze
February 2008